THE FINE

ARTS

SERIES

THEORY AND PRACTICE

HOW TO USE

MIXED MATERIALS

Acknowledgements

The Fine Arts Series was originated by Pieter
van Delft, ADM International BV,
Amsterdam and Bert Willem van der Hout,
Alpha Design BV, Utrecht

Research and text: Tine Cortel and Theo
Stevens
Editor: Carla van Splunteren
Translation: Tony Burrett and Carla van
Splunteren

Design: Bert Willem van der Hout, Alpha
Design BV, Utrecht

Cover photo: Pieter Paul Koster, with thanks
to Anton Martineau

Typesetting: Euroset BV, Amsterdam

Lithography: Nefli BV, Haarlem

Printing: Koninklijke Smeets Offset BV,
Weert

Illustrations:
Siert Koning, Amsterdam:
pages 9, 15, 17, 20, 30, 32, 35, 36, 39, 40, 46,
48, 49, 56, 58, 69, 70, 83, 84, 101, 104, 108,
110.
Koninklijke Smeets Offset BV, Weert:
pages 10, 11, 12, 13, 14, 50, 59, 62, 80, 81,
107, 108.
Theo Stevens, Amsterdam:
pages 18, 19, 21, 22, 23, 24, 25, 26, 27, 28, 29,
33, 34, 37, 38, 41, 42, 43, 44, 45, 47, 51, 52,
53, 54, 55, 60, 61, 63, 64, 65, 66, 67, 68, 71,
72, 73, 74, 75, 76, 77, 78, 79, 80, 81, 82, 83,
85, 88, 89, 90, 91, 92, 93,94, 95, 96, 97, 99,
100, 102, 103, 105.

For works of visual artists affiliated with a
CISAC organization the copyrights have been
settled with Beeldrecht at Amsterdam, The
Netherlands, © 1988, c/o Beeldrecht.

The publishers would like to thank (for advice
and materials):
Koninklijke Talens BV, Apeldoorn and the
importer for Koh-i-Noor in the Netherlands.

© 1990 Koninklijke Smeets Offset BV, Weert
ADM International BV, Amsterdam
and Alpha Design BV, Utrecht

English edition © 1990 by
David & Charles plc, Newton, Abbot, Devon

First published in Great Britain 1990
by David & Charles plc, Newton Abbot,
Devon.

Cataloguing in Publication data is available
on request from the British Library.

ISBN 0 7153 9880 6

THE FINE

ARTS

SERIES

THEORY AND PRACTICE

HOW TO USE
MIXED MATERIALS

DAVID & CHARLES
Newton Abbot · London

CONTENTS

THE FINE ARTS SERIES

THEORY AND PRACTICE

HOW TO USE
MIXED MATERIALS

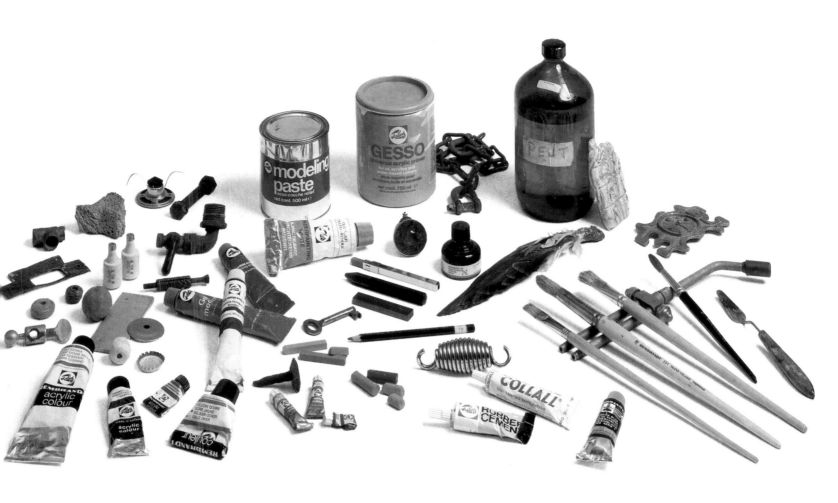

INTRODUCTION

Man has always felt a natural impulse to depict what he sees, to reflect his experiences pictorially and to give visual expression to his emotions. As far as we know, making art was one of the earliest of all human activities.

In the Stone Age our ancestors drew, painted and engraved on the walls of their caves and mountain shelters.

Besides drawing and carving on stone, ancient man carved in wood and engraved in sand and clay. He used organic and inorganic pigments to decorate his body, his accommodation, his possessions and his implements.

Coptic cloth – Fifth to eighth century

This fragment of textile was part of a large cloth manufactured from wool and linen sometime between the 5th and 8th centuries. Flower motifs and mythological figures are woven into it. It is one of the oldest known pieces of material.

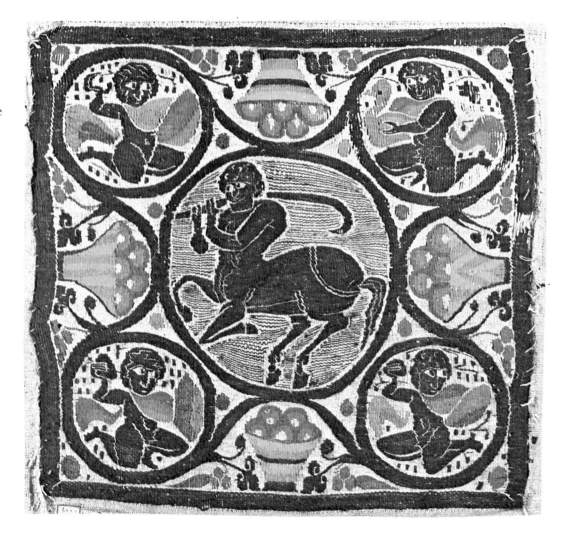

10

An example of this ingenuity is the piece of Byzantine artwork, made completely from bits of glass and small stones, which is illustrated on these pages. Images were often worked into other things – textiles, for example. This is strikingly illustrated by the piece of Coptic cloth which can also be seen on these pages.

A great deal of this early design has not withstood the test of time but, luckily, some has. It is clear that what we now regard as works of art were not then regarded as 'art', and therefore little regard was paid to the perishable nature of the materials which were used.

considered necessary for the piece of art he intended to make.

If we look deeper into the history of art we see that at a certain point in time artists no longer confined themselves to the use of traditional drawing and painting materials (both separately and in combination), but began to use those materials which we nowadays know as 'non-paint-related' – provided that they could be of the necessary quality and durability. For example, special glass was made, first for making glass mosaics and later for making leaded glass windows. This was one of the ways in which the use of mixed materials was revived.

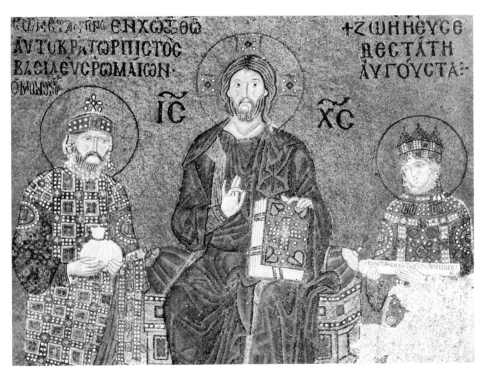

Christ between Constantine IX Monomachos and Empress Zoë – Probably executed between 1028 and 1034, defaced 1041, restored soon after 1042.

This Byzantine work of art is made entirely from small stones and pieces of glass and forms part of the mosaics in the south gallery of Hagia Sophia in Istanbul.

It was only when man developed the concept of 'making art' that he became concerned with the preparation of mediums such as paint, crayon and ink in which quality and durability were central. And only then did he develop materials with the specific properties that he

Right up to the present day, visual artists still use non-paint-related materials, both independently and in combination with the familiar drawing and painting materials. You will frequently come across the concept of 'non-paint-related' materials in this book. By non-paint-

related materials we mean everything other than paint and drawing materials.

It goes without saying that combining drawing and painting materials and working with non-paint-related materials requires a certain degree of skill. The intention of this book is to help those interested in drawing and painting to acquire this skill by providing them with a deeper insight into the handling of mixed materials and techniques and the opportunities these techniques offer.

In order to do this a description of the composition and properties of the various materials which can be used in mixed techniques is given, together with examples of pieces of work made in these materials or in which these materials are combined.

In addition there are a large number of material trials demonstrating the various ways in which they can be handled. We hope that those who are interested will make these trials for themselves and so gain practical knowledge and experience.

You will also find examples of how a visual artist uses mixed techniques to build up a piece of work. Four artists agreed to be photographed as they worked in order to allow you to follow the

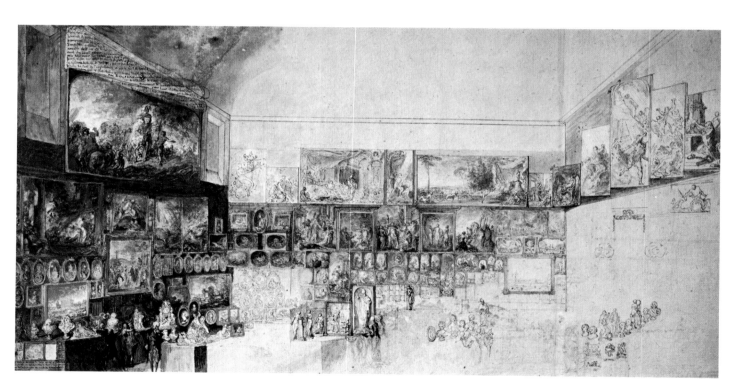

The Salon of 1765 in the Louvre
– 1765
GABRIEL DE SAINT-
AUBIN

This painting was executed in water colour and black Chinese ink. Gabriel de Saint-Aubin experimented with new painting techniques. He often worked out one or more parts of his paintings in a very detailed way and left other, larger, areas unworked.

process of creation step by step.

Finally there is a more technical section which provides information on such matters as supports, brushes, the composition of auxiliary materials and how to fix non-painted-related materials to supports, as well as instructions on how to prime and stretch supports. When you have absorbed all this information you will find that the technicalities of the actual work will be much simpler and that you will be able to direct all your attention and energy to the most important aspect of making a work of art – the expression of your ideas, thoughts and emotions.

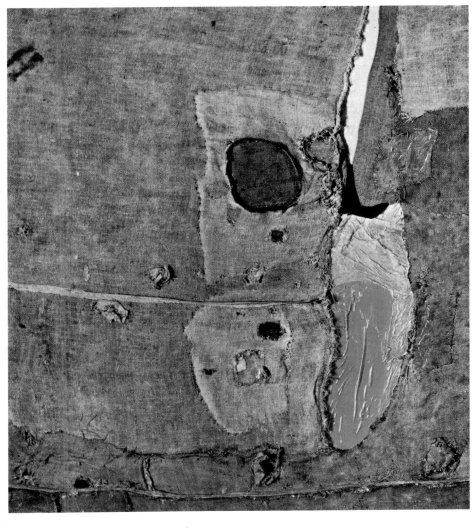

Sack No. 5
– 1953
ALBERTO BURRI

Sack No. 5 is one of a series of works which Alberto Burri made using sacks as his subject. He used the grain sacks just as he found them (complete with holes) and completed the work using oil paint.

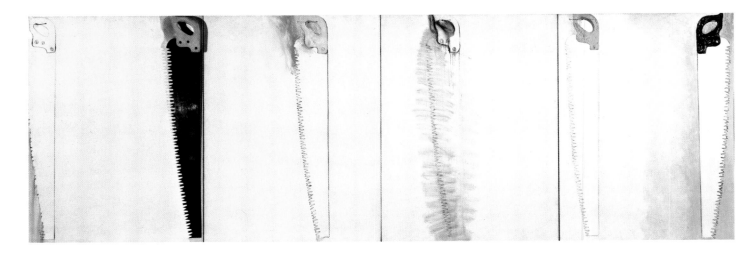

Six Large Saws
– 1962
JIM DINE

Dine's paintings are a medly of real and painted objects. In this canvas he used one real saw (left) and painted in five others.

Storm Over New York
– 1988
MARIE-FRANCE
KOK-ADAM

To make this picture, the artist first cut, sawed and trimmed clay tiles into the facets she wanted for her piece of work. These were pre-fired (to make soft biscuit tiles), glazed, and refired to achieve the true colours. The artist then assembled her tableau by fixing the tiles on a dark ground.

GRAPHITE AND CARRÉ CRAYONS

GRAPHITE

COMPOSITION AND PROPERTIES

In order to produce a drawing material, graphite is finely ground and mixed with dark clay which acts as a binding agent. The graphite-clay mixture is then extruded into thin spaghetti-like strings or pressed into blocks. After they have dried, these are then fired. The degree of hardness of the material is dependent on the proportion of clay to graphite and on the duration of the firing process. Graphite is an oily, soft material consisting of plate-like crystals. These are insoluble and are unaffected by the firing process. Clay hardens during the firing process and it is this material, therefore, that determines the strength of the drawing material which is produced.

Very soft graphite material contains only 30 per cent clay, for example, and is therefore very brittle. Because of the high percentage of graphite it contains, this soft material produces a deep anthracite black line. The more clay it contains (up to 70 per cent), the harder the graphite material is. With a high clay content and low percentage of graphite, this material produces a hard, sharp, grey line.

The following code is generally used to indicate the various degrees of hardness of graphite materials:

10B, 9B, 8B, 7B, 6B, 5B, 4B, 3B, 2B, B, HB, F, H, 2H, 3H, 4H, 5H, 6H, 7H, 8H, 9H

In general, B materials are used for creative drawing and H materials for technical drawing.

In some countries the code 0, 1, 1.5, 2, 2.5, 3, 3.5, 4, 4.5, 5 is used. In this code 0 is the softest and 5 the hardest graphite material. Lastly, there are additional codes – 00, 000 and BB, BBB, for example.

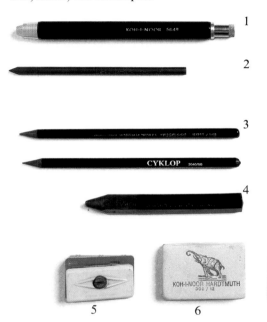

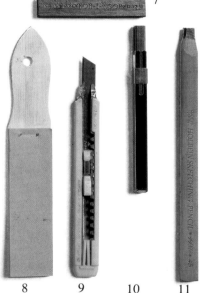

1 Mechanical clutch holder with sharpener
2 Graphite pencil for clutch holder
3 Round graphite pencil with plastic protective coating
4 Hexagonal graphite pencil
5 Sharpener with replaceable blade
6 Eraser
7 Graphite block
8 Sandpaper
9 Knife
10 Graphite carré in holder
11 Flat graphite pencil (joiner's pencil)

Graphite is available in many forms. The best-known of these is the ordinary graphite pencil. The pencil lead of good quality drawing pencils is glued into a cedar or poplar casing. Because of their brittleness soft leads are thicker than hard ones.

The flat, carpenter's pencil, which has a rectangular lead, is another form of graphite pencil. These are manufactured by Faber Castell, Holbein and Hardtmuth, among others. Loose leads for use in mechanical clutch holders are available in various types and thicknesses. The clutch holder manufactured by

Hardtmuth, which has a detachable top containing a pencil sharpener, is very useful. Besided graphite pencils and leads intended for mechanical clutch holders, thick graphite sticks are also manufactured.

These are covered by a thin layer of plastic or varnish. Round sticks are made by Bohemia Works, Faber Castell and Hardtmuth; hexagonal sticks by Baignol & Fargon and Faber Castell, among other manufacturers.

Finally, graphite carrés, which have specially designed holders, and flat graphite blocks (Hardtmuth) are also available.

AUXILIARY MATERIALS Thick graphite sticks can be sharpened with a craft knife or on a sandpaper block. Depending on the hardness of the graphite and the paper, areas of graphite that are unsatisfactory can be completely or partially removed with a soft rubber eraser. Graphite can be used on many different supports but the type of graphite used must be suitable for the support chosen. It is better not to use paper that is too thin, particularly if working to a large format, because graphite has a certain 'sharpness' and can easily damage the surface of the paper. Soft graphite adheres to practically any support. Adhesion problems only arise with supports which have an extremely smooth surface texture, such as glossy synthetic materials and shiny metal.

Hard graphite adheres well to supports which are less absorbent and which therefore have a smoother surface texture. Graphite carrés and blocks, which can be used to lay down large areas, produce very good results when used on more textured papers such as, for example, aquarelle paper. The grain of the paper gives an extra texture to the graphite. Use soft sticks if you wish to achieve distinct differences in tone and harder sticks for finer, more delicate drawing.

It is not necessary to fix graphite drawings. They can be protected by laying a sheet of paper between them. Try to avoid dropping graphite materials as they break easily.

The leads in pencils can also break and should therefore not be used as drumsticks! If they are, you will discover the results when you sharpen them. Use point protectors or the tops of old felt pens or ballpoint pens to protect your pencils and sticks.

CARRÉ CRAYONS

COMPOSITION AND PROPERTIES The natural types of crayon, known as carré crayons because of their rectangular cross-section, contain inorganic and organic pigments which give them their colour.

Colours such as ochre, umber, sanguine and white are obtained from inorganic pigments. These colours are usually prepared from metal compounds found in the surface soil. Bistre-coloured and black crayons contain organic materials which, among other ways, are released by various carbonisation and combustion processes. The greys contain both inorganic and organic materials.

The pigments used in the manufacture of carré crayons are almost always prepared synthetically nowadays. This is for two reasons: firstly, many original deposits have been worked out; and secondly, synthetic pigments give a better consistency of colour.

Water and a binding agent are added to the raw materials, which are then mixed to form a paste. Oil is also added for some types of crayon. Various sieving techniques are used to remove any hard particles which could eventually damage the support. The purified paste is extruded in lengths or pressed into shape and then dried in drying ovens. Some of these are then fired. Firing is a baking process which is carried out at various temperatures. The difference between unfired and fired types of carré crayon can be found in the degree of hardness and the nuances of colour. A low tem-

perature and a short firing period produce a fairly soft material in light colours. The higher the temperature and the longer the firing period, the harder and darker in colour the material becomes. In addition, carré crayon can be oil-free or oil-containing.

Well-known types of carré crayons are those made by Faber Castell, Hardtmuth and Conté à Paris, among others, but the quality of the material is not always indicated in the same way by different manufacturers. Hardtmuth, among other manufacturers, supplies special holders for graphite crayons. These allow you to use your crayons down to the last remnants.

AUXILIARY MATERIALS Because of its powdery nature, this material requires a fairly absorbent support in order to ensure that the crayon particles adhere well to the surface. Types of paper such as casing, cover paper, Ingres and primed universal board are particularly suitable. Crayon is also very suitable for using on tinted paper, especially if the tint plays an important role in the piece of work you are making.

The crayon can be handled vertically or horizontally so that it is possible to work in both line and flat areas. Lines and areas can also be laid down over each other.

Nuances in texture and tone can be achieved by varying the pressure exerted on the material. Areas of crayon can be rubbed with the fingers or worked with kneadable rubber or a stump (see below). Areas of your drawing can be lightened by dabbing them with a piece of kneadable rubber. The particles of crayon which adhere to the rubber are dispersed by kneading it. The rubber can then be used again. Eventually, however, the rubber becomes saturated with particles of crayon and can no longer be used for this purpose.

A stump (or tortillon) consists of pressed felt or paper. Colour nuances can be created, or excess crayon removed, by gently rubbing it over an area of crayon. Loose crayon particles can be removed by tapping the back of the support.

Colour nuances can also be achieved and excess crayon removed by means of a duck's wing feather.

A crayon drawing can be fixed with a special fixative in order to prevent damage to the surface. To do this, simply follow the instructions on the package.

Carré crayons attract moisture. So do supports. They should therefore be stored in a dry place.

Fixative is highly inflammable and must be stored in a cool, frost-free place.

Store your duck's wing feather in a box to protect it from moths.

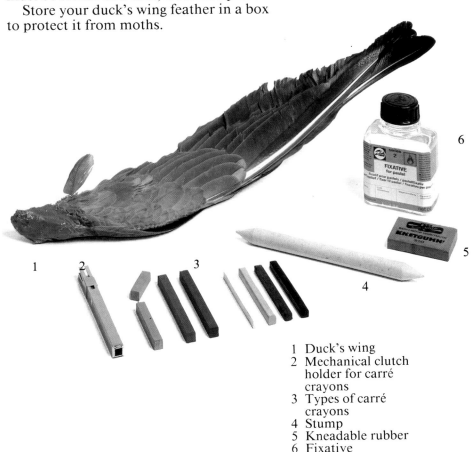

1 Duck's wing
2 Mechanical clutch holder for carré crayons
3 Types of carré crayons
4 Stump
5 Kneadable rubber
6 Fixative

APPLICATIONS AND MATERIAL TRIALS

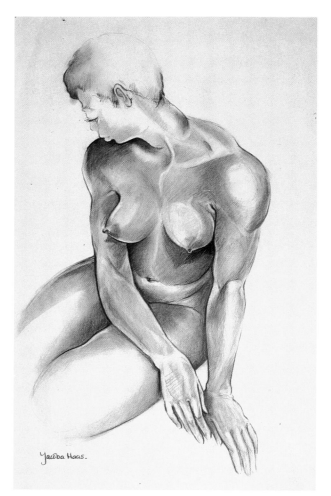

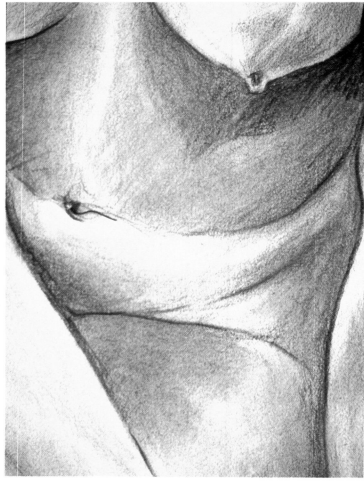

Negro - Girl
– 1987
JACOBA HAAS

Jacoba Haas made this drawing of one of her models with graphite and black carré crayon on tinted paper.
By using these two materials she was able to achieve a strong contrast in tone. The graphite is particularly used for the soft grey tones of the dark skin. Hatchings were laid down over rubbed areas of shadow in order to heighten the effect of light and dark.
Areas of light were achieved by leaving the paper unworked and areas of graphite were lightened with a piece of kneadable rubber. Both of the effects obtained created highlights in the drawing. Highlights are those accents in a piece of work which are the lightest and brightest in tone.

The much blacker carré crayon was largely used in the heavier outlines and for the accents in the hair.
The position of the hands holds both the model and the composition of the drawing in balance.

Detail: the combination of graphite and carré crayon is clearly visible in this detail from the drawing. You can also see how the artist handled her materials.

Graphite and carré crayons

Material trial I
(Graphite)

Deep, anthracite-black tones can be achieved using a soft graphite stick. The graphite can only be lightened or removed with an eraser if it is laid down applying little pressure to the stick.
Harder graphite sticks are especially suitable for laying down hatchings and applying sharp accents.

Material trial II
(Carré crayon)

You can work in both lines and flat areas with carré crayon. It is also possible to lay down lines and areas over each other.
A more dreamlike atmosphere can be created by rubbing the carré crayon with the fingers. The area is partly lightened using kneadable rubber.

Material trial III
(Graphite and carré crayon)

Carré crayon and graphite each have their own particular 'feel'. The slightly glossy, anthracite-black, soft tone of graphite contrasts with the black, dull tones of the carré crayon. White carré crayon tones down the black tones to greys. This toning-down process is also suitable for laying down highlights in your composition.

SOFT PASTEL

COMPOSITION AND PROPERTIES Soft pastel consists of a large quantity of pure pigments ground together with a very fine binder (kaolin or China clay).
If other binders are added, the pastel becomes hard and loses its velvety character.

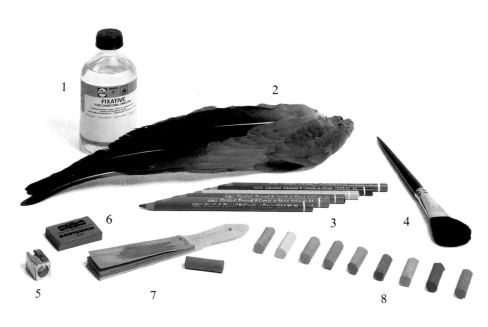

1 Fixative
2 Wing
3 Pastel crayons
4 Wash brush
5 Sharpener with large aperture
6 Kneadable rubber
7 Sandpaper
8 Soft pastel

The required nuances of colour are obtained by adding black or white to make the colours lighter or darker.

The paste is then pressed into strips, cut to the required length and dried. Good quality soft pastel is soft and contains no hard particles. It should be bright in colour and not fade when exposed to sunlight.

Working with soft pastel creates dust and it is possible that you might inhale pastel particles or transfer them to your mouth by way of your fingers. For this reason the pastel must be absolutely non-toxic. If you are allergic to certain materials it is advisable to wear a simple paper mask while you are working.

In buying soft pastels ensure that they are non-toxic and that the strength of colour and degree of resistance to fading are known. Reliable manufacturers provide this information either on the material itself or in their catalogues.

Talens, for example, supplies a high-quality soft pastel in more than 200 colours and provides all the information mentioned above. These pastels have kaolin – a very fine type of clay – as a binding agent. Kaolin, a strong binder, is colourless.

Soft pastels are available in round, short and long sticks (Talens, among others) and in carré sticks (Hardtmuth and Grumbacher, among others). Pastel pencils are also available (Hardtmuth and Conté à Paris, among others).

AUXILIARY MATERIALS Soft pastel sticks can be sharpened on a sandpaper block while pastel pencils can be sharpened with a wide-aperture sharpener (these pencils are a little thicker than graphite pencils as a rule).

Pastel pencils are fairly soft and point protectors should therefore be used.

With softpastel it is best to use fairly absorbent supports so that the material can adhere easily to the surface. Cover paper and Ingres, which are available in various tints, are both highly suitable supports but hardboard and universal board also satisfy the requirements.

Soft pastel sticks are suitable for drawing in both line and area, while pastel pencil is the best material for the execution of finer drawings and for laying down finer accents in works executed with pastel sticks.

Rubbing the pastel colours into each other is one of the possibilities offered by this medium. This process can be carried

out with the fingers or with a stump or tortillon.

Areas can be lightened or partially erased with kneading rubber. Areas of pastel can also be mixed or rubbed out with a stiff-haired brush.

If several layers of pastel are laid down over each other it is advisable to provide the area of colour with a thin intermediate layer of fixative. This increases the power of adhesion.

Fixing a piece of work can also protect it to some extent against damage. Always use a fixative intended for soft pastel and follow the given instructions. The layer of fixative darkens the surface of the pastel a little and for this reason some artists prefer not to fix their drawings but to mount them directly behind glass. Protect your pastels by placing a sheet of paper between the drawings and by ensuring that the drawings cannot slide over each other. Store your pastels, pieces of work and unused supports at room temperature and keep the fixative somewhere cool.

APPLICATIONS AND MATERIAL TRIALS

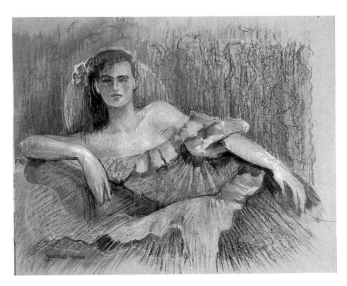
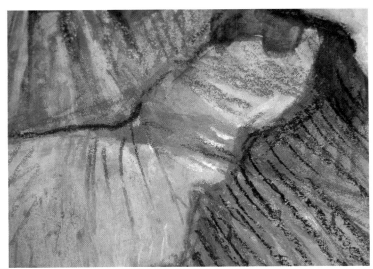

The portrait of the Spanish dancer is drawn in soft pastel and carré crayon. Finer pastel pencils were used in the details.

It goes without saying that the materials mentioned, all of which are types of pastel, complement each other very well.

The drawing was executed on grey board. This type of cardboard has a fairly open surface texture, which means that the fine particles of the drawing materials are able to adhere to it easily.

Jacoba Haas has incorporated the grey tone of the support into her piece of work so that it is expressed well in the final representation.

In the execution of this drawing, the artist first made a sketch in blue and pink pastel crayon. This was then worked on further with water in order to create paint-like effects.

The drawing was then laid down with pastels, pastel pencils and carré crayon.

Detail: the way in which Jacoba Haas works can be observed in this detail. The dancer's dress was laid down in carré crayon over washed areas of pastel. The eventual effect of these lines is created by the underlying layers of pastel. In this detail it is also striking how Jacoba Haas made use of the various properties of the material and the opportunities these offered. When she wished to achieve paint-like effects she reached for her brush and dissolved the pastel in water. The last accents were laid down in carré crayon.

Spanish Dancer
– 1988
JACOBA HAAS

Mobil Oil I
– 1988
BESSEL KOK

Bessel Kok sees himself as a reporter of life in pictures. If we follow him in his work we see him as an explorer in search of the unknown. His reportages brought him in contact with industry. Fascinated by human activity in different technical environments, he captured this activity in a large number of pastel drawings, some of which exceeded a metre in size.
Mobil Oil I is a typical example of this. Kok worked on the spot, on heavy aquarelle paper, using only soft pastel. The grain of this type of paper adds extra texture to the pastel, which he rubs only sporadically. He keeps his colours bright by using fixative while he is working. In his work, Bessel Kok always works around a principal colour based on a primary colour and matches the other colours to this. When he chooses his principal colour, Kok does not begin with the natural colours he sees, but from the feeling his subject arouses in him.

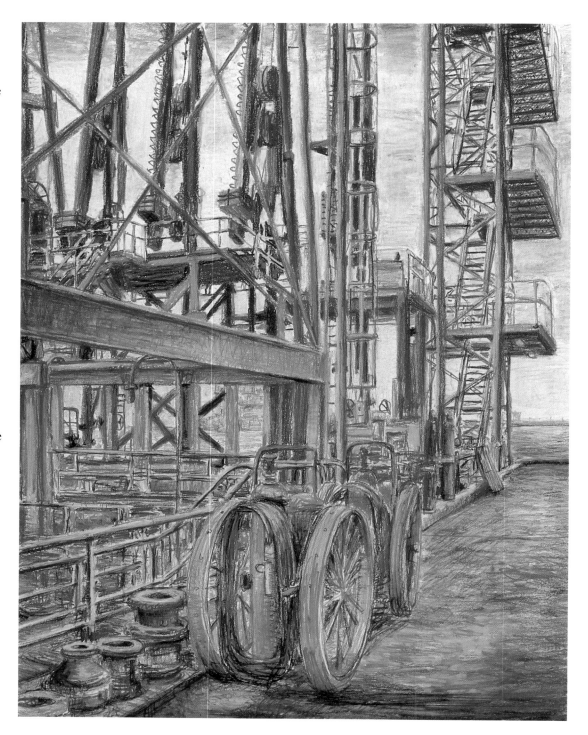

Soft pastel

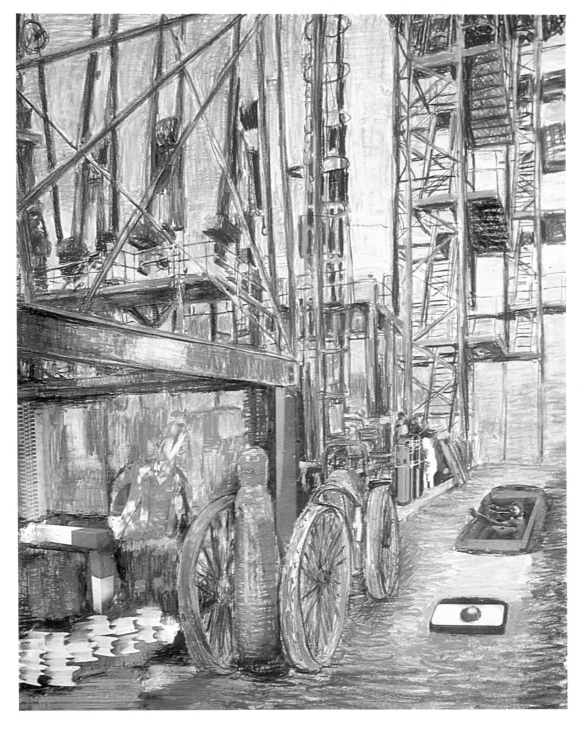

Mobil Oil II
– 1988
BESSEL KOK

As he captured the many technical locations in which he found himself – often on commission – Bessel Kok came under the influence of the machines themselves and he began to ascribe human characteristics to them. This created an interaction between man and machine and led to a transformation of the original theme. To do this, Kok developed a highly personal technique in which soft pastel and paper collage featured together. Contrast was created by using photographic material from magazines. The use of non-paint-related materials in his pastel drawings creates tension and gives his works an extra dimension. This can be seen clearly if you compare *Mobil Oil I* and *Mobil Oil II* with each other. The platform of the refinery is completely transformed and seems to radiate a strange air of secrecy. Notice the collages, among them the humanized oxygen bottle in the foregound. The tools and equipment take on a life of their own. The collages were pasted down with a dextrine-based glue and then fixed with a protecting spray to prevent discolouration.

Material trial **IV**
(Soft pastel)

Pure colour can be laid down again over areas of rubbed pastel. Do not use too many colours as this 'kills' the colour of the plane.
Such an area of 'dead' colour can be partially 'brought back to life' by rubbing it with kneadable rubber. However, don't forget that prevention is always better than cure!
Areas can also be laid down without rubbing. To do this use the pastel flat or cover an area by hatching.

Material trial **V**
(Soft pastel, carré crayon and collage)

Soft pastel is a welcome complement to the natural colours of carré crayon. The two materials work excellently in combination when used, for example, to lay down areas of colours which are very similar in nature and in tone.
Try to make a small collage completely within areas of pastel. This technique requires a considerable degree of imagination and creativity.

An artist at work

In the reportage Bessel Kok shows how he uses paper collages in a pastel drawing. The subject, Man and Machine, is a transformation from a pastel which he made on location at the chassis line – where car chassis are assembled at the DAF factory.

As is the case in many workshops, the electric tools here are connected by long electric cables and air hoses which crisscross the area high above the heads of the workers. These cables assume an important role in Bessel Kok's pastel drawing.

His studio is full of large pastel drawings, some of which he is still working on. A large table, with dozens of trays of soft pastels, neatly arranged by colour, a pot of paste, huge piles of old magazines and selected pictures which he has already torn out and with which he will work, are the most important materials used by Bessel Kok to build his own world.

Bessel Kok with his pastel drawing
The Chassis Line

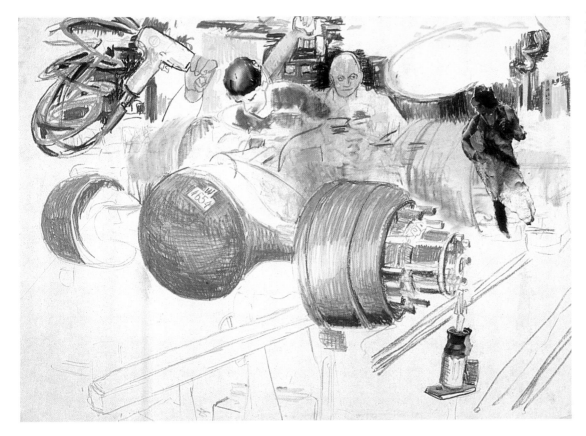

I The pastel is executed on a large sheet of black aquarelle paper. In order to immerse himself deeply in his work, Bessel Kok makes a careful plan before he begins. He believes that corrections and changes adversely affect the surface of the paper. After he has completed his basic planning, the design is lightly sketched in soft pastel and he begins to work out the main shapes. To do this he chooses a primary colour – in this case, red – which will form the main tone in this work. Already in this first phase collages are laid down.

II (*Detail*) To begin with the paper collages are fixed in place only with a touch of paste so that it remains possible to move elements around. In this detail you can see how Kok has built up the workman out of separate parts of various photographs. In this way the position can still be changed. This paper collage is partly enclosed by touches of pastel so that it already forms part of the whole image. Kok uses pastel fixative as an intermediate varnish when he lays down more layers of pastel over each other.

III In this phase it is clear that Kok has first directed his attention to the moving parts of the chassis line. This movement is central to his drawing. The curving pastel lines in the foreground emphasise the rotational movement of the subject. The tints used in the backgrounds are purposely kept cool. This means that this part of the picture tends to recede and it also forms a contrast with the warm reds used in the car component in the foreground.

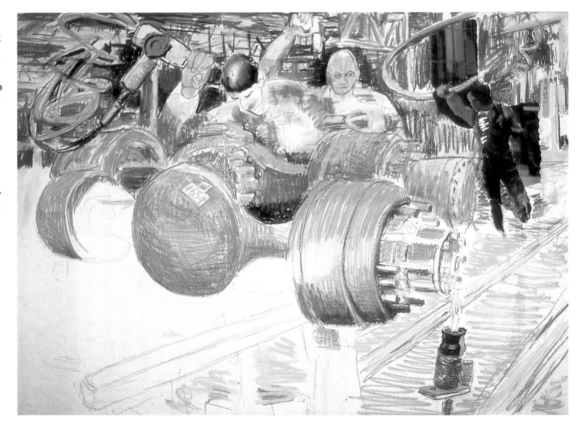

IV (*Detail*) Compare this detail with the first. Here you can see the flexible way in which Bessel Kok handles his paper collages. The position of the head is altered, while a piece of paper has been added to the body to give an extra accent. The workman has also been given another right arm. The manner in which the hand – pulling a cable towards the figure – transfers from the collage to the pastel drawing is quite ingenious.

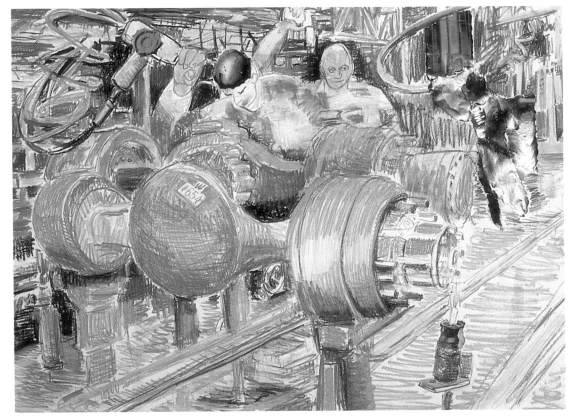

V The large car component in the foreground has now been fully worked out. This phase is a good illustration of the way in which the paper collages work within the pastel drawing. In order to achieve this the original forms of the collage images were changed and they were used in a different way, being transformed into the setscrew of the drill, the helmet, the blowtorch and the industrious workman.

VI (*Detail*) This part of the pastel emphasises the mobile tangle of hoses and cables, and could almost be called menacing. It also contains a clear philosophical observation. According to Kok: 'Man will become entangled in his own inventions. He will be pushed more and more into the background because the machines he has produced make him superfluous. The machine will thus become more and more humanised.'

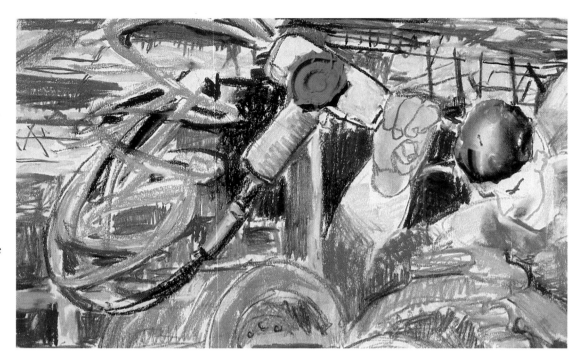

VII The floor only slowly becomes a part of the whole. This must remain very tranquil. Because the floor is situated in the foreground of the pastel there is a danger that it will actually stand out too much. For this reason the most important elements are worked out first and their colours determined.

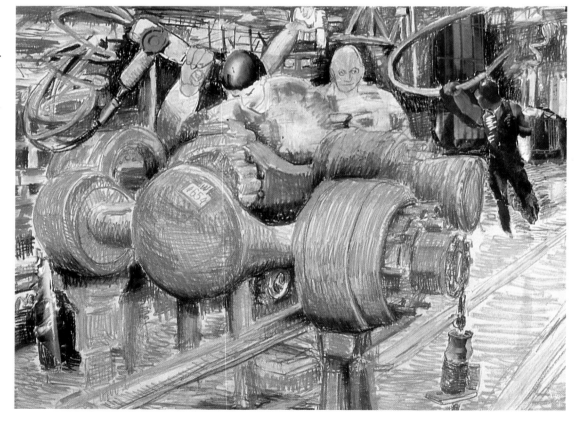

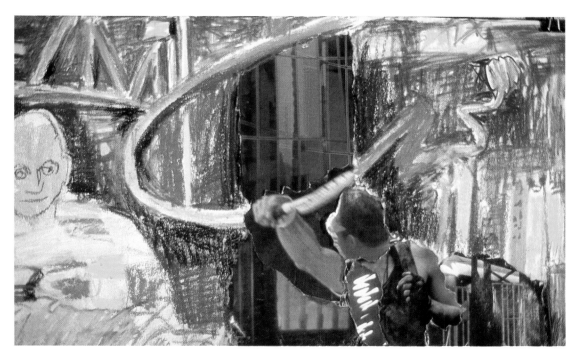

VIII (*Detail*) In his work Bessel Kok seeks a balance between technique and image. He feels very strongly about technique but believes that it must be subject to the contents of his piece of work. The balance between technique and image is also important when he is working with paper collages. While these collages must create an effect which it is not possible to obtain only in pastel, they must also form an essential and integral part of the pastel as a whole.

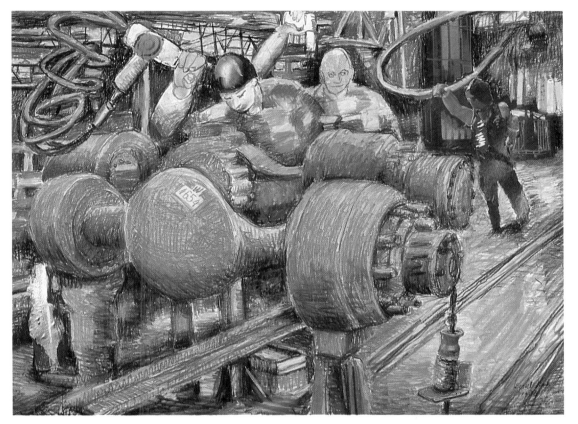

IX The floor is laid down in full colours only in the last phase of the drawing. The green, yellow and blue harmonise and despite their brightness still remain tranquil. The rhythmic repetition of the pastel strokes also enhances this feeling, as it does in the depiction of the moving parts in the drawing. The drawing is fixed to protect the collages from the effects of light and the pastel against possible damage.

WATERCOLOUR PAINT AND WAX CRAYON

1 Palette box with
 pans of water-
 colour
2 Fixative
3 Coloured pencils
4 Acid-free paper
 adhesive tape
5 Water container
 with spring and
 strainer
6 Collapsible water
 container

WATERCOLOUR PAINT

COMPOSITION AND PROPERTIES Water-
colour paint consists of pure, very finely
ground, mainly transparent pigments
bound with gum arabic. This gum is clear
and has excellent binding properties.

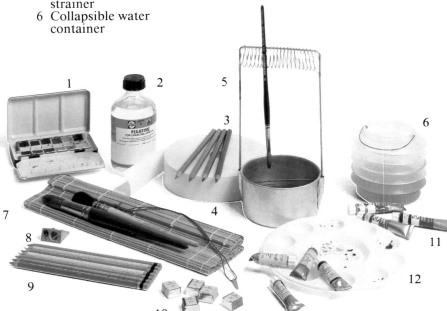

+++ highest degree of resistance to
 fading
++ a good degree of resistance
+ low degree of resistance
 (colours in the last category do not
 appear in this Talens assortment)

The pigmentation and price category of
each colour is also given in Talens' cata-
logue. The paint is supplied in tubes and
in block form.

AUXILIARY MATERIALS Special, strong-
ly sized paper is manufactured for water-
colour painting. During the preparation
process the surface of the paper is
pressed and this gives it a fine or rough
texture.

The pressing remains visible, because
watercolour paint is transparent, while at
the same time it also gives texture to the
layers of paint. Light is reflected by the
paper and this gives the paint an attrac-
tive glow.

Primed universal board is also a good
support tot use with watercolour paint,
especially when used in combination
with other visual materials.

Paper absorbs a great deal of moisture
when watercolours are used and there-
fore has a tendency to cockle. It will nev-
er regain its original form when it has
dried. This paper, in particular, must
therefore be stretched. The paper is first
soaked in a tray of water until it has
stretched to its limit. Excess water is then
removed by laying the paper between two
sheets of absorbent paper.

It is then laid on a flat surface and the
edges fixed in place with acid-free adhe-
sive tape. Do this by first taping down
two opposite sides and then the remain-
ing two.

The flat position in which the paper is
held ensures that it dries evenly. During

7 Brush holder with
 watercolour
 brushes
8 Sharpener with
 apertures of
 various sizes
9 Watercolour
 pencils
10 Pans of water-
 colour
11 Watercolour in
 tubes
12 Watercolour pal-
 ette

Watercolour paint is thinned with water
and is not water resistant after drying.

Both professional and students' paints
are available. Professional paints contain
only very good pure pigments; in stu-
dents' paints expensive pigments, such as
the cadmiums and cobalts, are replaced
by cheaper pigments. It goes without say-
ing, therefore, that the colours vary in
price. The degree of resistance to fading
is an important factor. Talens indicates
this on the packaging of the paint using
the following code:

drying the paper shrinks and becomes flat and tight. The paper will again cockle when watercolours are used on it but as the paint dries the paper will stretch again because the edges are fixed in place. The painting is then cut loose from the surface.

Round, pointed, soft-haired brushes, and sometimes a flat brush, are used in watercolour painting. Brushes made from polecat hair and red sable hair are the most suitable. These are expensive types of hair but they are durable and retain their shape well and, as long as they are looked after properly, will last a long time. Soft filament, a synthetic fibre, is a reasonable alternative but holds water less well than polecat and red sable hair.

Tubes and blocks are often packaged in a metal box which serves as a palette. If this is not the case, then you need a watercolour palette; this has shallow depressions pressed into it to hold the liquid paint.

The art of watercolour painting involves laying down layers of well thinned watercolour paint one over another to create an optical colour mixing effect. This can be done on either dry or wet paper. On wet paper the paint spreads strongly. Areas of white are created by leaving the paper unworked. Sometimes Chinese white is used to lay down white accents. White pigments are never completely transparent, however, and for this reason many artists avoid using them.

Watercolour pencils are also available (Hardtmuth and Derwent, among others, supply these). They can be used independently or as a complementary material to watercolour paint. This material dissolves in water. It can be used on either wet or dry paper and areas and lines can be worked with a brush after they have been laid down.

Remnants of paint can be saved. If each colour occupies a fixed position on the palette, additional paint can always be added to it. In this way no paint is ever wasted. Always cover an open palette to protect the paint from dust.

Watercolour paint should be stored in a cool, frost-free place.

Soft-haired brushes should never be left standing in water because this deforms their shape. Special jars, furnished with a spring coil to hold the brushes, are available. Squeeze out the brushes after use and press the hairs into their original shape.

Store them in an upright position in a jar or protect them by rolling them up in a brush holder.

Watercolour pencils can be thicker than ordinary graphite pencils and therefore should be sharpened either with a knife or with a sharpener with two different sharpening apertures.

Watercolours are not varnished. Watercolour drawings made with watercolour pencils can be protected against light by spraying them with a charcoal or crayon fixative. This must be sprayed thinly from a distance of half a metre in order to prevent the paint running.

Store fixatives in a cool, frost-free place and finished paintings at room temperature.

WAX CRAYON

COMPOSITION AND PROPERTIES Wax crayon is prepared from pigments with various waxes and oils as binding agents. The raw materials are ground into a fairly stiff paste and pressed into lengths or blocks. Thin lengths are mounted in wood in the same way as pencils. Thick lengths are mounted in wood or wrapped in paper.

The material is non-toxic, bright in colour, does not smudge and is water-resistant.

The degree of resistance to fading was formerly very low, especially when wax crayons were still regarded as drawing and colouring material for children. A number of manufacturers have woken up to the fact that wax crayons are being used more and more by artists, and have paid particular attention to improving

their resistance to fading. Although a guarantee of this is given on the package, it is nonetheless necessary to carry out colour trials to determine which colours are the most resistant.

Hardtmuth, Caran d'Ache and Bruinzeel, among others, are reliable makers of crayons.

The assortment of wax crayon blocks (2.5 x 4 x 1 cm), produced in West

AUXILIARY MATERIALS Wax crayon yields the best results on heavier types of paper such as drawing and aquarelle paper. Colours lose their brightness when it is used on tinted paper.

Pencil, crayon and blocks yield good results when used in combination with each other. Colours laid down over one another give a mixed colour, and thicker layers of wax crayon can be scratched in

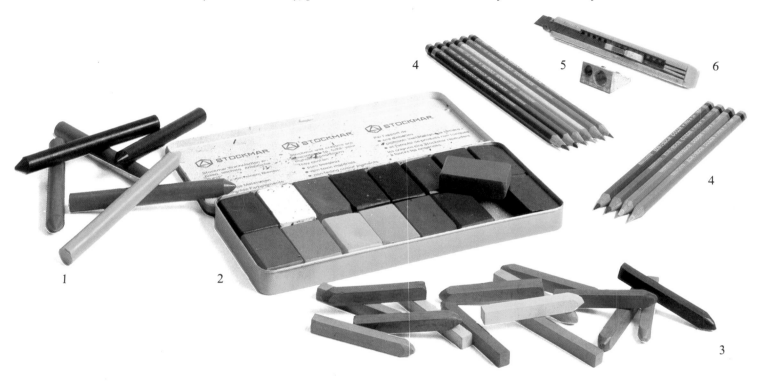

1 Round wax crayons
2 Blocks of wax crayon made with honey
3 Carré wax crayons
4 Coloured pencils
5 Sharpener with apertures of various sizes
6 Knife

Germany and sold under the brand name 'Stockmar Wachsfarben' is very good. This assortment consists of 14 bright colours, black and white. These blocks are manufactured from pure beeswax, are non-toxic and have a high degree of resistance to fading. They can be used to lay down vigorous lines as well as areas of colour.

Filia offers an assortment of 36 good quality small wax crayons under the name 'Olikridt'. These crayons, which should not be confused with oil pastels, are suitable for making line drawings. The colours are rather subdued.

order to reveal underlying colours and to create a different structure.

Wax crayon cannot be removed with an eraser. A sharpener with two different sharpening apertures is useful as this allows pencils and crayons of various thicknesses to be sharpened. A sharp knife is also suitable for this.

Wax crayons make no special demands as far as storage is concerned but pieces of work should be stored in a frost-free environment.

Applications and material trials

Tamil Nadu, India
– 1988
Jörg Remé

The small watercolour *Tamil Nadu* is an idealised mental picture of a journey Remé made in Southern India, and is intended as a preliminary study for a large oil painting which would be executed at a later date. The forms of the people, animals and vegetation are highly abstract and reflect the abstract nature of the human memory.

The composition contains many round forms which are complemented by a number of taut shapes. These taut forms balance the round ones and increase the tension in the composition. This watercolour paint is complemented by wax crayon in order to increase the plastic effect of the various forms.

Remé does not apply linear perspective in his work but creates an effect of depth through differences in the nuances of colour he lays down. Remé calls this 'in-the-wings perspective' because the shapes are situated in front of and behind one another.

Detail: the transitions from watercolour to wax crayon, which has been laid down over dried layers of watercolour, are barely visible. Remé used the same range of colours in the wax crayon transitions that were used in the watercolour painting.

Despite the fact that a great deal of colour was used in the watercolour, the impression of colour is not excessive but actually rather subdued.

Material trial **VI**
(Watercolour paint)

Optically mixed colours are created by laying
down a number of layers of watercolours over
each other. Areas of white are created by leav-
ing parts of the paper unworked. The accents
here were laid down in watercolour pencil.
Watercolours flow freely when applied on
wet paper and the effect this gives can yield
excellent results when it is incorporated into a
composition. If too much reliance is placed
on these coincidental effects, however, a wa-
tercolour painting has little value.
Try to avoid unwanted flowing effects or
use a dry brush or sponge to stop the paint
spreading.

Material trial **VII**
(Wax crayon)

Because of their fine points, coloured pencils
are best suited for executing lines, laying
down areas by means of hatching and indicat-
ing accents.
 Wax crayon blocks, however, can be used
to lay down large, even areas of colour which
are not streaky in appearance. These blocks
yield the best results when used on rough-
grained paper.

Material trial **VIII**
(Watercolour paint and wax crayon)

Wax crayon used in combination with water-
colour paint retains its texture when it is laid
down over areas of paint that have dried.
Wax crayon is a greasy material which does
not dissolve in water. If you lay down thinned
watercolour paint over an area of wax crayon,
the crayon will reject it.

Indian ink and oil pastel

Indian ink

COMPOSITION AND PROPERTIES Indian ink – which is also known as Chinese ink – originally came from the Far East where ancient cultures used it as a writing, drawing and painting material. This ink was prepared from very fine soot obtained from camphor oil. Hard sticks, which could be kept indefinitely, were made by a lengthy kneading, shaping and drying process. A deep black, fluid ink was obtained by rubbing the stick with water on a special inkstone. Later, coloured ink sticks were also produced.

Although Indian ink in solid form is still imported from the East, it is no longer of the quality it once was, although it is perfectly adequate for our purposes. Fluid Indian ink was being manufactured in the West as long ago as the 15th century, and today many brands of good quality ink are available, among them Chinese and Japanese types.

Like the ink made from ink sticks, this pigmented (soot) ink is water-resistant and resistant to fading after it has dried. Because the pigments are not soluble in water, they eventually sink to the bottom of the bottle. For this reason the ink should be thoroughly stirred before it is used.

AUXILIARY MATERIALS Ink can be applied using sharp metal pens, reed pens made from bamboo and soft-haired brushes. Never use this type of ink in an ordinary fountain pen because the pigment particles and the medium which makes it water-resistant will clog it up. Nowadays special fillable pens and cartridges for use with Indian ink are available (Holbein and Osmiroid, among others).
A smooth support which has a compact

texture is necessary when you are drawing with a sharp pen. Drawing paper and ivory board, among others, are suitable supports. All types of paper are suitable when you are working with a reed pen or brush.

Indian ink can be used in its pure form or thinned with water. Before you begin to work you can prepare a few mixing

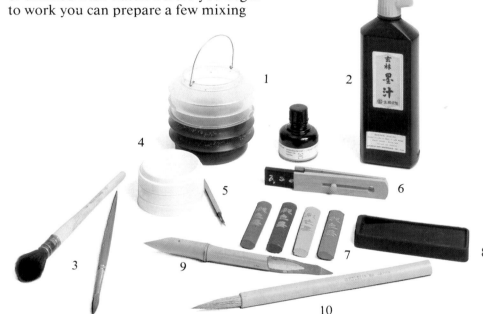

1 Collapsable water container
2 Liquid black Chinese (Indian) ink
3 Watercolour brushes
4 Stackable mixing containers
5 Metal pen in holder
6 Ink tablet in bamboo holder
7 Solid coloured ink
8 Stone for rubbing solid ink
9 Bamboo reed pen
10 Eastern brush made from goat's hair

palettes with thinned ink so that you have various black and grey tones at your disposal. The water in which you rinse your brushes can also be used.

When you have finished working, rinse your brushes out immediately so that the pigment particles do not dry. Should this happen, your brushes will no longer be usable.

Graphite can be used to remove dried ink from metal pens. To do this, place the pen on a flexible surface – a piece of foam rubber, for example – and remove the ink carefully with the point of a graphite pencil.

Avoid getting spots of ink on any article of clothing. If this should happen, rinse it immediately in a good deal of lukewarm water. Do not rub the spot because this forces the pigment particles (which are not soluble) into the fabric.

As mentioned before, Indian ink is water-resistant and therefore pieces of work made in Indian ink do not need to be protected.

Ensure that the top of the bottle is screwed on tightly and store the ink in a cool, frost-free place. Pieces of work should be stored at room temperature.

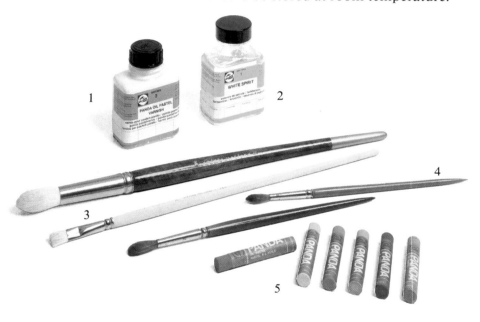

OIL PASTEL

1 Varnish for oil
 pastels
2 White spirit
3 Stiff-haired brushes
4 Soft-haired brushes
5 Oil pastels

COMPOSITION AND PROPERTIES Oil pastel is a type of crayon in which pigments are ground into a paste with waxes and oils, extruded into lengths and then cut to the required size. They undergo no further process.

The waxes and oils that are used as binding agents make oil pastel a soft, very greasy material.

At higher temperatures the material becomes soft and tends to smudge. In this condition it can be worked with a painting knife.

Oil pastel is water-resistant but can be rubbed.

The colours are pure although it must be said that not all of them have a high degree of resistance to fading. It is better, therefore, to make a series of colour samples to discover which colours are least susceptible to daylight. In its catalogue, Talens indicates the resistance to fading of each colour separately.

Oil pastels can be obtained in sets or individual sticks. When working with oil pastels it is inevitable that your hands come into contact with the material and it is therefore important that it is non-toxic. Oil pastels supplied by Talens and Filia, among other manufacturers, are non-toxic but there are also good Eastern brands available.

AUXILIARY MATERIALS Depending on the manner in which oil pastel is used, it can be applied to absorbent paper (cover paper and Ingres, for example), textured paper (aquarelle paper and casting, for example) as well as on smooth supports (ivory board, for example).

The material is suitable for working both in line and areas of colour. When oil pastel is used on well-sized paper, it is possible to rub in the pastel with your fingers, to scratch it, to scrape it with a knife or to work into it with white spirit or turpentine. White spirit or turpentine dissolves the pastel and creates interesting pictorial effects.

If you work in a warm room or outdoors in sunlight, oil pastel becomes soft. It will recover its original consistency, however, if you put it in the fridge.

Oil pastel is susceptible to smudging and it may therefore be necessary to varnish a piece of work. A special oil pastel varnish is available for this purpose and you should simply follow the instructions on the package.

Oil pastels, white spirit and varnish must be stored in a cool, frost-free place. Brushes should be rinsed in white spirit. Store pieces of work in a fairly warm, dry place.

APPLICATIONS AND MATERIAL TRIALS

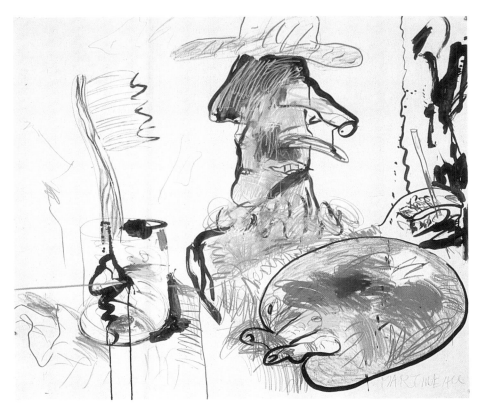

The drawings that Anton Martineau makes using mixed materials are more than a metre in height and width. They are Expressionist but also contain Surrealist elements. Martineau works spontaneously; he wants to express himself powerfully and without constraint. He cannot do this if he confines himself to a small format and therefore he chooses a smooth, slightly-tinted type of paper so that his work is not restrained. As the artist himself explains:
'In my drawings I give dimension to the paper by including it in the overall conception and the tint also allows me to use white materials. The danger of working in this spontaneous, almost reckless, way is that you must always be on the alert to ensure you don't come a cropper! I use various materials. The material is important in relation to how strongly it works.
You must always be conscious of the balance between materials. Graphite, for example, is passive and easily suppressed by other materials. Indian ink is obstinate. Oil pastel must not be too heavy or it becomes dominant.'

Detail: the various materials appear to have been used indiscriminately but Martineau knows what he is doing. The artist is of the opinion that a wide knowledge of his material is essential particularly when working in this way.
He must be able to lay his hands instantly on the exact material he requires at any given moment. In order to be able to do this, Martineau has arranged his materials in a large, flat box divided into compartments. Each material and each colour has its fixed place in this box.
In this detail you can observe how first graphite and wax crayon, and then oil pastel and Indian ink were laid down. Martineau used the ink to make the shapes stand out from the whole.

The Painter and his Model: – a Toothbrush – 1988
ANTON MARTINEAU

Material trial IX
(Indian ink)

Pen and ink were suitable for making line drawings and for laying down structures. Delicate lines can be created by varying the pressure exerted on the pen. Structures can be created by means of simple hatching and crosshatching.
Various black and grey tones can be produced by diluting the ink with water.

Material trial X
(Oil pastels)

Areas of oil pastel can be worked with a knife in such a way as to reveal the underlying colours. Use a piece of smooth paper for this trial piece.
When a little white spirit is applied to areas of oil pastel, they can be worked on further after they have dried.

Material trial XI
(Graphite, wax crayon, oil pastel and Indian ink)

When you are working with different materials it is important to use them in the right order. Graphite and wax crayon were used first in this trial piece. Both these materials are soft in tone. Oil pastel was then laid down over dried Indian ink.
The same trial carried out in reverse order demonstrates that graphite does not adhere to oily materials. A thin layer of oil pastel does not reject Indian ink, a thick layer does.
Oil pastel is greasier than wax crayon and can therefore be laid down over it.
Wax crayon loses its brightness when it is laid down over an area of ink; oil pastel, however, remains bright in colour.

CHARCOAL

COMPOSITION AND PROPERTIES The best charcoal is obtained from the twigs of a Japanese shrub, but willow, lime and vine twigs can also provide good charcoal.

The twigs are sorted by thickness, length and straightness. After a careful drying process they are fired in vacuum ovens.

Various degrees of hardness can be obtained depending on the duration of this carbonisation process. These are usually indicated by a code from 1 to 5.

Good charcoal is deep black, and the crosscut end of the stick must be a uniform black. Badly carbonised charcoal is greyish-black and may contain hard particles. Many good varieties are available.

SIBERIAN CRAYON (COMPRESSED CHARCOAL) Siberian crayon consists of powdered charcoal mixed with clay and pressed into sticks, and is blacker and denser than charcoal sticks. The same fixative is used for Siberian crayon as that used for charcoal.

Special holders are available so that small lengths can be handled easily.

CHARCOAL PENCILS Charcoal pencils have the same composition as Siberian crayon. Faber Castell, Hardtmuth and Conté à Paris, among other manufacturers, are well known suppliers of charcoal products.

AUXILIARY MATERIAL Charcoal yields the best results when it is used on absorbent paper. For example, novel paper and cover paper – available in various colours – are suitable for studies and quick sketches. These types of paper are not resistant to fading, however and Ingres, white as well as tinted, is perhaps a better paper. Siberian crayon and charcoal pencils can also be used on more strongly sized papers such as drawing paper and aquarelle paper.

Charcoal and Siberian crayon are soft, dry materials. The way in which they are

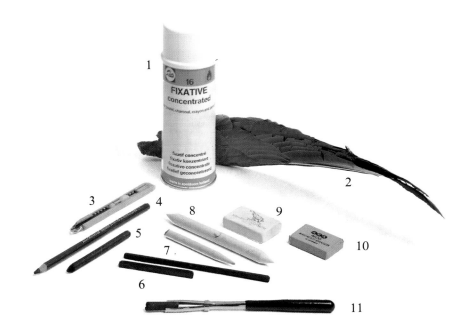

handled is similar to that in which carré crayons and soft pastels are used – the difference being that they have no colour.

The material is suitable for laying down lines or areas, and can also be worked with the fingers, duck's wing, stump or tortillon. Areas of charcoal can be lightened with soft rubber or kneading rubber.

Charcoal drawings are vulnerable and should be fixed with a fixative suitable for charcoal and crayons. It is sometimes advisable to fix the drawing during working as this allows the charcoal to adhere better. Store both drawings and materials in a dry place, and fixative in a cool, frost-free place.

1 Aerosol fixative
2 Wing
3 Knife
4 Charcoal pencil
5 Charcoal crayon for use in a clutch holder (Siberian chalk)
6 Charcoal
7 Tortillon
8 Stump
9 Eraser
10 Kneadable rubber
11 Clutch holder for charcoal and crayon

APPLICATIONS AND MATERIAL TRIALS

Still Life
– 1988
MARIAN VAN UNEN
(student)

Marian used Siberian crayon to make a free sketch which she then finished in watercolour. It is a study in the laying down of various shapes showing their areas of light and shadow. This method of working is a good exercise in learning how to handle the material in order to create flowing lines. To do this the movement is made from the shoulder, elbow and wrist and not limited to the fingers. When you are practising in this way, do not support your arm on the working surface as this inhibits freedom of movement. Fast, free sketching is also a good way to learn how to lay down the outlines of a shape. The touches of watercolour only indicate the areas of shadow, and light is indicated by leaving the paper unworked.

Material trial **XII**
(Charcoal)

Siberian crayon is deeper in tone than charcoal, and is suitable for laying down sharp accents in an area of charcoal.
It is possible to lighten smooth areas of charcoal with kneading rubber, as long as the paper can withstand this treatment. In this trial piece the texture of the paper and the charcoal work well together.

Material trial **XIII**
(Charcoal and watercolour)

When you are using watercolour paint and charcoal in combination, the charcoal sketch should first be fixed so that the carbon particles do not dull the paint. If you wish to add further charcoal accents then wait until the paint is dry.

AN ARTIST AT WORK

When we asked Anton Martineau if we could record the various stages in the creation of one of his drawings, he agreed immediately.

Martineau has his own clear opinions on the uses of different materials in one piece of work and will therefore leave nothing to chance. He begins from the standpoint that one must know what effect a particular material produces in a piece of work, and this knowledge is acquired by a good deal of hard work and wide experience.

Because Martineau had decided to work largely with graphite and various types of crayon he chose a large sheet of slightly tinted aquarelle paper.

Martineau is not only a talented visual artist, he is also very well able to put into

words exactly what he is doing and why he is using a particular technique. He explains his work below.

Phase I Siberian chalk
'My work is mobile and spontaneous. I may later wish to move elements of my drawing which have already been laid down, and in order to give myself the opportunity of doing this I begin by using a material which is not too irrevocable. To reposition elements I brush away the pressed charcoal and redraw them. If necessary, I can work further on the smudges this creates.'
'Pressed charcoal, which is usually known as Siberian chalk, is a tonal material. Even if it is not necessary to move elements, I lay down charcoal tones by rubbing the material into the texture of the paper with my fingers.'
'I use the chalk powerfully in those places where I am absolutely sure of what I am doing – as I did here in the man who is walking and the moon.' The nocturnal animal is laid down more thinly, because I intend to do something else with that later.'

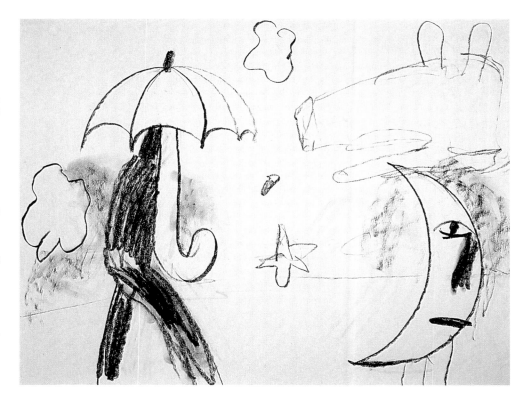

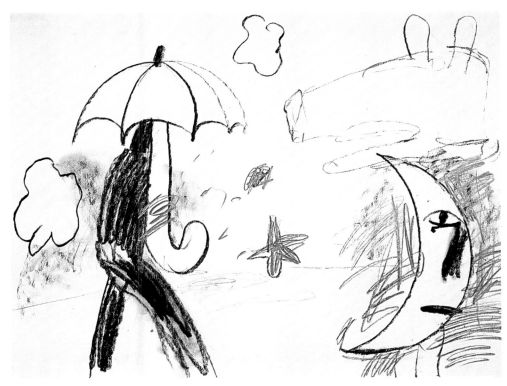

Phase II Graphite

'The order in which the material is used is important in a mixed technique drawing. In the first instance the combination must be well-considered from the point of view of the technical properties of the materials.'

'I chose graphite for a number of reasons. From the point of view of technical application, graphite can be laid down over charcoal. From the artistic point of view, graphite creates less heavy areas in the drawing than Siberian chalk so that I can achieve accents which are rather lighter. Moreover, graphite gives a linear structure and therefore creates a different "feel" than tonal charcoal.'

'The order in which the materials are used is important. I can't lay down charcoal over areas of graphite, for example, because it doesn't adhere.'

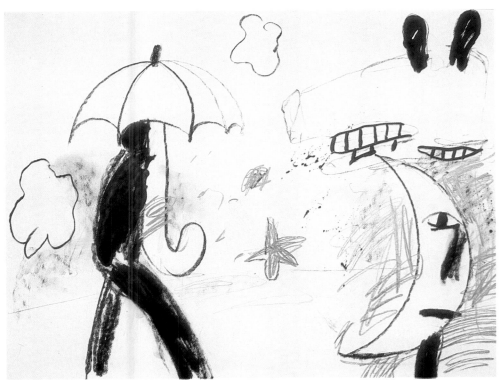

Phase III Black Chinese (Indian) ink

'I use black Chinese ink to bring out the most important details in the drawing – the walker, the face of the moon and the animal's teeth and ears.'

'I give depth to the drawing by spattering a little ink in places. Now the title of the drawing becomes obvious to me – *Restless Night with a Walker*.'

'So far as the composition is concerned the paper is now clearly divided into two with the walker on the left and the restless night on the right. The element of movement binds them together, however.'

'The walker steps into the restless night. It is not raining. The umbrella is more an indication of protection, of concealment, of security.'

Phase IV Wax crayon (coloured)
'If you decide to use colour in a
black and white drawing then
you should be aware of what you
wish to achieve by the addition.'
'Colour must never be used sim-
ply to fill in shapes or as a
makeshift expedient for reme-
dying a drawing which is not
successful. Adding colour must
heighten the expression in the
drawing. If it doesn't, then the
decision to use it was unwise and
the colour is superfluous.'
'In this instance I have decided
to use wax crayon. Oil pastels,
which are much more oily and
bright, would tend to dominate.
If the colour accents are too
heavy, I will lose the black ac-
cents which I have already
achieved.'
'There is no risk of that happen-
ing when I use wax crayon. This
material has a less emphatic
colour and gives a streakier tex-
ture so that the area of colour re-
mains more "open".'

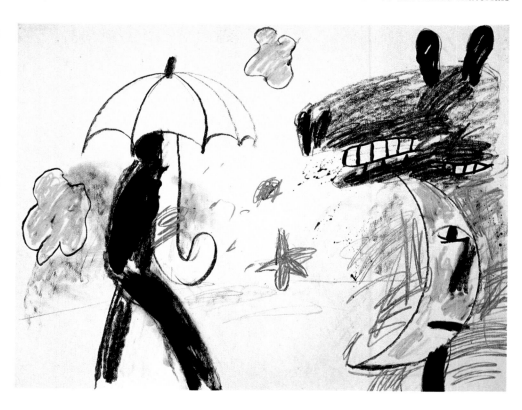

Detail: 'You can see the "open"
texture in this detail. You can
also see that the texture of the
paper adds an extra structure to
the crayon.'
'I can lay down wax crayon over
an area of ink, but if I lay down
ink over wax crayon then the
wax rejects the ink. Dried areas
of ink have a fairly high gloss. If
you lay down ink over an area of
charcoal then the ink layer is
beautifully matt.'
'I do not use expensive red sable
hair brushes for this because the
soot particles in the ink would
eventually damage them. I could
easily destroy the tension which
I have achieved in my spon-
taneous black and white drawing
if I overstep the mark in the use
of colour.'

44

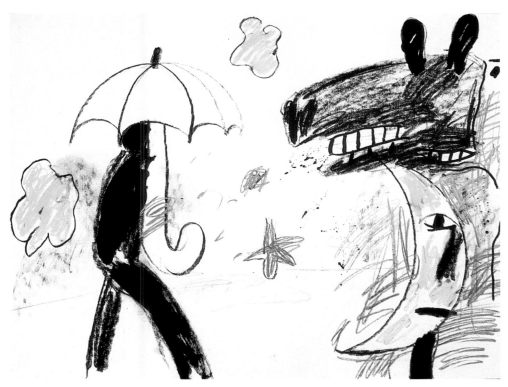

Phase V Wax crayon and graphite.
In this last phase it is no longer possible to make corrections. What now exists is irrevocable. If there is anything wrong then I can better start again. This is in contrast to the charcoal drawing which could still be changed. What I must now look for are those points which require further work.'
Just how litte additional work is required can be seen from the few accents which are now applied to make the animal complete. The night behind the animal is strengthened with graphite so that this area has more uniformity. Anton puts down his graphite. He has achieved what he wanted to achieve.

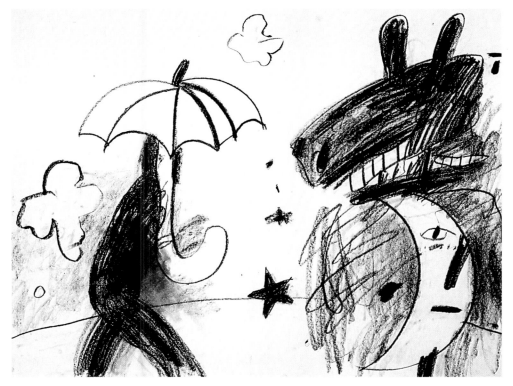

Black and white drawing

The subject of the walker, the moon and the nocturnal animal has kept Martineau busy for quite a while and he has made several versions. We have chosen one of these.
The drawing appears to be identical to the one he has made for us, except that it contains no colour. If we look more closely, however, we can see important differences between the two drawings.
The black and white drawing was made on pure white paper with deep black Siberian chalk so that there is a hard, sharp contrast. This makes the content of the drawing much more threatening than the last one he made. This is a little less tense and has a rather more fairy tale-like feel. The tension is reduced by the use of colour and the tint of the paper and thus the drawing is less oppressive.

GOUACHE

1 Stackable mixing
 containers
2 Water container
 with divider
3 Jars of gouache
4 Varnish for
 gouache-mat

COMPOSITION AND PROPERTIES
Gouache (poster paint) is an opaque
water-based paint. The strong, bright,
colour pigments are supplemented by
white opaque extenders such as lithopone
and precipitated chalk, but these white

little water it retains its opacity. If more
water is added the pigment particles,
which are not dissolved in the binder,
become more thinly dispersed and the
gouache takes on a transparent character.
As the paint dries the binder ensures that
an adhesive film, in which the pigment
particles are held, is formed. The dis-
persed pigment particles remain clearly
visible (in contrast to what happens with
good quality watercolour).

AUXILIARY MATERIALS Working with
opaque, barely diluted gouache requires
a strong support which is somewhat
absorbent so the pigment particles can
adhere to it. Casing, cover paper, Ingres,
aquarelle and drawing paper, among
others, are suitable types of paper.
Cardboard, white and grey board, the
rough side of hardboard, plywood, chip-
board and universal board can be used as
rigid supports.

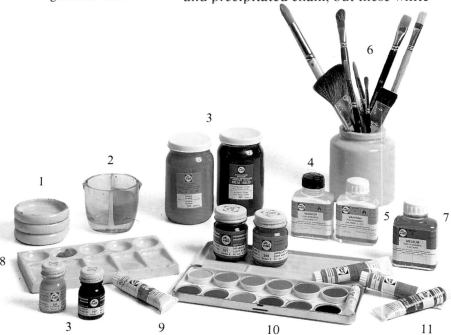

Flexible canvas is less suitable for use
with gouache because the dried paint
layer can crack and peel away.
 A support which is too absorbent can
be primed with a gouache medium. This
medium can also be added in limited
quantities to the paint, but the paint then
becomes a little more transparent and to
some extent loses its mat appearance.
 Use a watercolour palette with
gouache. If a large amount of paint is
required then it can be prepared in a
mixing bowl.
 All types of brushes can be used when
working with gouache. Round and flat
hog's hair and filament brushes can be
used when the gouache is applied
opaquely and polecat, goat and red sable
hair brushes when the paint is applied
transparently.
 If large areas of gouache are to be laid
down this should be carried out in a

5 Varnish for
 gouache-glossy
6 Stiff- and soft-
 haired brushes and
 spalters
7 Medium for
 gouache
8 Palette for water-
 colour
9 Opaque white
10 Box with blocks of
 gouache
11 Tubes of gouache

pigments do not affect the brightness of
the opaque colour pigments.
 The binding agent used in gouache
paints consists of dextrin – which is man-
ufactured from potato flour – and gum
arabic. The paint can be thinned with
water and is not water-resistant after
drying.
 Gouache is not suitable for working in
thick, paste-like layers as these would
tend to crack on drying.
 Gouache dries to a matt finish and be-
comes lighter in colour than it is when
wet. The paint is available in tubes and
blocks.
 When gouache is diluted with only a

single operation. The paint dries quickly and any overpainting will remain visible. The paint can be applied opaquely or transparently in several layers with an intermediate drying time. A hairdryer can be used for this. It is also possible to work in wet paint layers in which case the colours will mix.

Pieces of work can be varnished, although this is not necessary. Both gloss and mat varnishes are available. Mat varnish has little influence on the colours, gloss varnish makes the colours rather darker and the gouache a little more transparent. A gouache painting can also be lightly sprayed with a charcoal or crayon fixative. This gives some protection to the paint surface without changing the colours. When varnishing and fixing, follow the instructions on the packet.

Gouache is sensitive to frost and should therefore be stored in a frost-free environment. Remnants of dried paint can no longer be used, so cover still-wet remnants with a thin layer of water.

Clean the brushes thoroughly in lukewarm water and store them upright in a jar. Protect unvarnished and unfixed pieces of work with a sheet of paper and store them in a dry place.

APPLICATIONS AND MATERIAL TRIALS

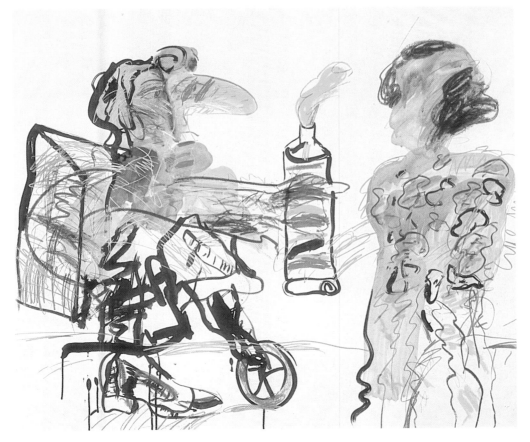

An Exuberant Passer-by – 1988 ANTON MARTINEAU

Martineau has a spontaneous way of drawing and chooses a material he can use in a powerful way. This drawing was made on smooth paper with watercolour, graphite, black Chinese (Indian) ink, oil pastels and gouache. Because of its effect each material has its own specific place in the drawing. The graphite, for example, is kept in the background, while the black ink stands out strongly in the foreground.

Magical Happening
– 1969
THEO SCHABBING

Magical Happening is painted in gouache, has accents in graphite and contains almost invisible collages incorporated into the paint film. It is painted on paper mounted on a sturdy support which has paper stuck on the back to prevent warping.

Schabbing prepares his gouache himself because he considers manufactured gouache to be too finely ground and without texture. He also needs a great deal of paint for his large paintings and finds it less expensive to prepare his own.

His own gouache is composed of pigments with a good quality cellulose size as a binding agent. This type of size is pure, does not decompose and has good adhesive properties. The pigments and size are mixed but not ground. This produces a rather grainy gouache with the texture the artist requires. The paint is mixed in large pots into a semi-liquid paste. If an extra touch of colour seems necessary during painting, it is mixed from pigment and size directly on the palette.

The paint is applied with hog's hair brushes, sometimes rubbed in with a sponge or partially lifted. Both the layered painting technique and the wet-in-wet technique are used. The paint layers remain wet for a considerable time so they can be worked on for a long period. New structures and effects are created by wiping off layers of paint with paper.

Theo Schabbing did not originally begin with a pre-determined theme. According to Schabbing himself: 'It is an interplay between me and the paint.'

'The work is built up without a preliminary

sketch. The composition only becomes clear while I am working and only then can I work it out. The aim of using graphite is to indicate obvious accents. It is also useful in obtaining greater clarity and is partially painted out if a particular accent appears to be superfluous.' The painting is Abstract-Expressionist but also contains elements of Realism.

The magical happening takes place inside and outside the painting. A cloud drifts into the picture from the top right hand corner. The blue area recedes and suggests the open air, while the white area in the foreground stands out strongly. This creates a great effect of depth. Schabbing: 'It appears as if, to amuse himself, a magician is setting off fireworks and playing with shapes. Allowing them to float and fall.'

Detail: when Theo Schabbing is asked the object of his paper collages, which are so carefully incorporated into the paint film, he pauses a little before replying: 'They are actually not intentional, although they create a plastic effect because they stand out a little from the painting. They are accidental, a result of necessity. My strong approach damaged the paper.'

'When I repaired the damage I incorporated the collages in the form originally intended. It is just a knack. After all, Rembrandt did it as well!!'

Tatlin at Home
– 1920
RAOUL HAUSMANN

A little explanation is necessary for those who want to understand this piece of work which is composed of gouache and photo-montages. Dadaism was a revolutionary movement which began in 1915 in Switzerland and spread throughout Europe and America. A decade later this movement made way for Surrealism. The name 'Dada' (the French word for 'nonsense') symbolised a deliberate, irrational, anti-aesthetic position which was partly a reaction to World War I. The aim was to destroy art as an aesthetic cult in order to replace it with a meaningless, shocking anti-art.

Dadaists such as Raoul Hausmann, Vladimir Tatlin and Kurt Schwitters rejected established art forms and instead used existing objects and collages, which had not originated from their own creative efforts.

In Hausmann's photo collage *Tatlin at Home*, the revolutionary Russian sculptor is central. A machine is mounted inside the human skull. In the background stands a worker indicating that his pockets are empty. Hausmann, who after a period of painting concentrated on photography, made similar photo montages,

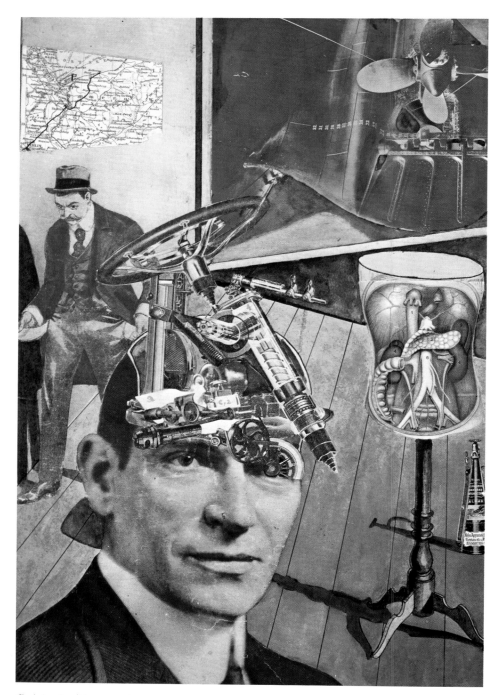

finished with gouache, after World War I. *Tatlin at Home* is an example of these.

Material trial **XIV**
(Gouache)

Layered paintings can be made with gouache.
The underlying layers must be thoroughly dry.
A layer must be laid down quickly so that
those underneath have no chance to dissolve.
If this should happen, a layer of opaque white
(Talens) can be first applied. This prevents
the underlying colours showing through.

The Alla Prima technique can also be used
with gouache. In this wet-in-wet technique,
in which painting is carried out in wet paint
layers, the colours mix together. Consider be-
forehand which mixed colours will be created.

Like transparent watercolour, gouache is
suitable for combining with many other
visual materials.
In this trial gouache, watercolour, graphite
and crayon have been used.

AN ARTIST AT WORK
(Gouache, red clay and charcoal)

At first sight it may appear that the combination of gouache and charcoal is not an obvious one because charcoal can dull the colours in a painting. In his gouache *Annette*, however, Bob ten Hoope shows us that when it is used skillfully, charcoal can enliven colours rather than dull them.

Art critics have frequently spoken of the 'animation' in Bob ten Hoope's work. He makes dynamically charged, impressionistic work in an emotional, highly personal style, primarily executed in gouache, charcoal and oil paints. In this painting, Bob ten Hoope first applied gouache and then used charcoal and red clay. (The latter he brought back with him from the Ardêche in France.)

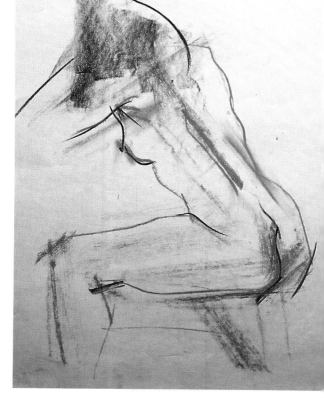

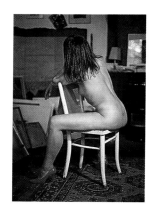
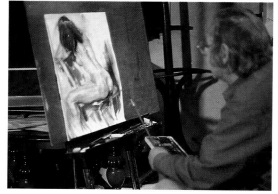

He has a close relationship with his model, Annette, and she knows precisely what Ten Hoope wishes from her as a model. During the two and a half hour sitting in which the gouache *Annette* was created, Bob ten Hoope not only proved that he is a very good artist but Annette made an important contribution by posing untiringly for him.

I Bob ten Hoope begins by making a preliminary sketch, using a piece of dry, red clay. He prefers this material because it is soft in tone and so the sketch is not as emphatic as it would have been had it been made with charcoal. The outlines of the model are laid down in red clay. He positions diagonal lines to indicate the line of the shoulder and back. He then lays down blacker tones in charcoal in order to establish the darkest areas of the drawing. He also changes the position of the arm. The composition has a clear diagonal line.

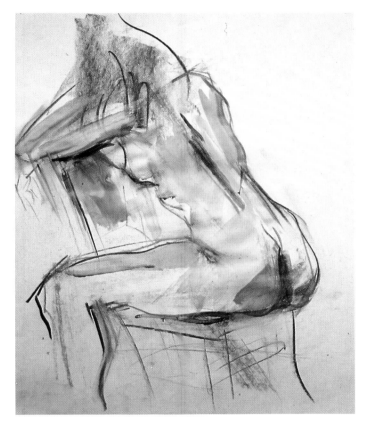

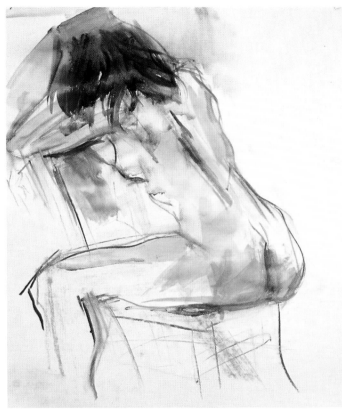

II First, the more definitive shape of the body is indicated in charcoal and the chair sketched as a support for the arm and buttocks. The first areas of colour are then laid down in well-thinned gouache. The most important areas of shadow are now established. The bluish-green colour used in the body comes about because the foliage outside creates a greenish light in the studio. The red area of the scarf is also laid down as support for the arm.

III The hair and background are now painted and the background around the head accentuated. The shape of the arm is also improved. The hair is worked on further with charcoal.
Ten Hoope is continually aware of the anatomy of the body. With his eyes half closed and his arm outstretched, he paints imaginary lines in the air as if he wants to sense the shape before he sets it down. He works in short powerful strokes, using round and flat hog's hair Gussows.

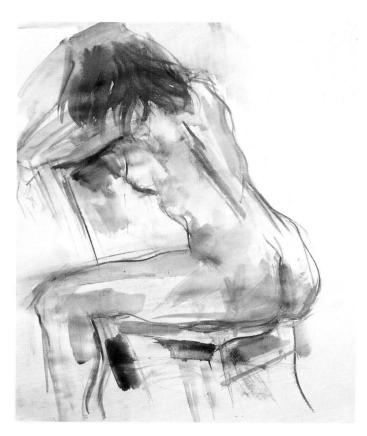
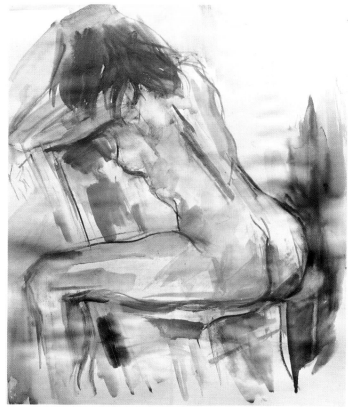

IV Bob ten Hoope alternates between layered painting and the wet-in-wet technique (see page 51).
The body is now completely recorded in colour and the areas of shadow in particular receive attention. The coloured areas of the red cloth and seat of the chair are laid down and now form an entity with the model.
The artist positions his paint strokes in such a way that the clay and charcoal lines laid down earlier are not completely covered but still retain a function within the painting.
This is especially visible in the contour lines of the body and the lines which indicate the backbone.

V The paper was not stretched wet. The large amount of water in the thinned gouache causes it to stretch and cockle. The areas of colour in the red scarf and chair are broadened and emphasise the diagonal line of the body. Because the whole painting has a diagonal direction, a strong feeling of movement towards the top left hand corner is created. There is the danger that the model appears 'to be moving out of the picture' and to prevent this, and to keep the composition in balance, the artist lays down a heavy area in the background on the right hand side.

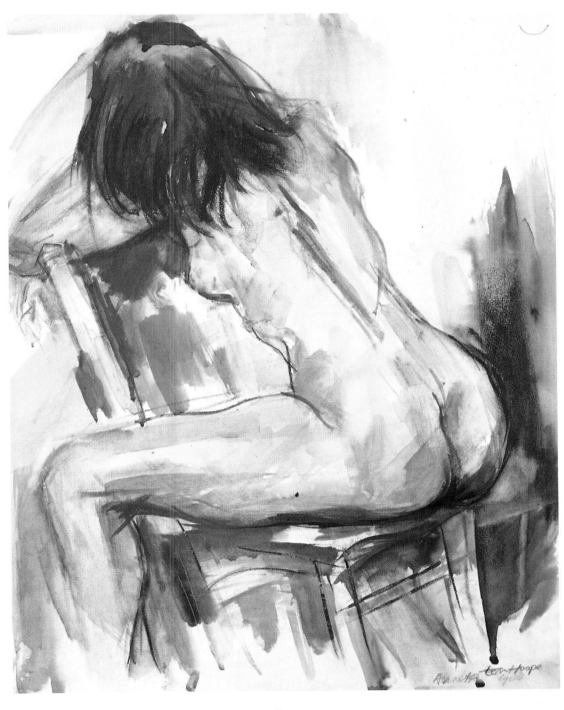

VI The entire painting is now looked at again and shapes and areas of colour strengthened. The bluish-black hair is given a few additional charcoal accents. There is now more transition in the areas of colour. The painting has become more restful although it still retains its mobility. Study especially the manner in which the background is painted. The positions of the different colour areas all have a function. Not one of them appears superfluous. The paper was mounted on a rigid support because it was not completely flat.

OIL PAINT

COMPOSITION AND PROPERTIES Oil paint consists of extremely finely ground organic, inorganic and synthetic pigments, bound with drying oils. Linseed, poppy and safflower oil, among others, are used for this purpose.

The advantages of synthetic pigments, which can be of the highest quality, are that they contain no contaminating agents, are consistent in colour and have a high degree of resistance to fading.

They are ecologically sound because flora and fauna – which provide most of our natural pigments – are not used in their manufacture.

The quality of the binding agents is also important. They must have optimum transparency together with the least possible tendency to yellow. Yellowing affects the colours.

Oil paint must be bright in colour, highly resistant to fading and dry evenly.

1 Tins of oil paint
2 Various shapes of brushes made of natural hair and artificial fibres
3 Pigments
4 Oil paint palette with tubes of oil paint
5 Oil painting sticks

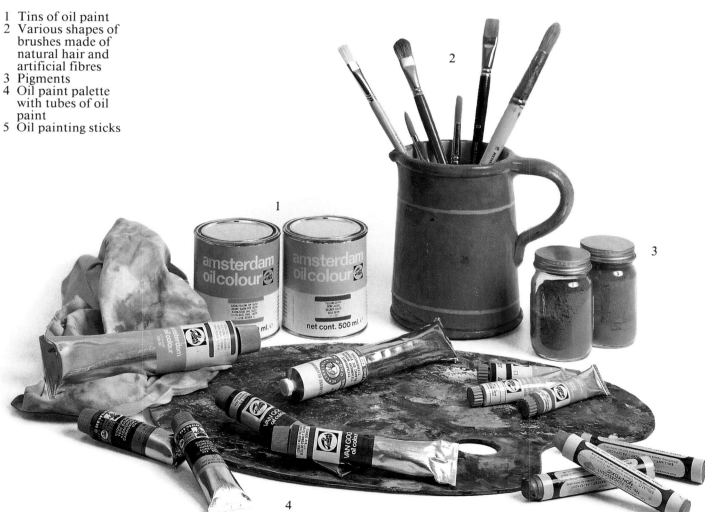

The drying time of oil paint is dependent on the type of oils it contains.

Oil paint that is not bright in colour or dries poorly contains adulterated pigments and has a poor balance between pigments and binding agents. After it has dried oil paint is water-resistant.

Both professional and students' paints are available. Professional oil paints contain only high-quality pigments. In students' paints the most expensive pigments, particularly the cadmiums and cobalts, are replaced by less pure pigments like phtalo and ultramarine.

Moreover, students' paints are often a little less highly pigmented. Good students' paints (Talens, among others) are nonetheless a satisfactory medium.

Oil paint is available in tubes, cans and in the form of oil painting sticks (Markal Company, USA, among others).

Not all oil paint colours have the same opacity. A colour can be opaque, semi-opaque, transparent or semi-transparent, depending on the pigment used. For some painting techniques – such as glazing, in which predominantly transparent colours are used – it can be important to know the opacity of the paint.

The whites, cadmiums and cobalts, for example, are opaque or semi-opaque pigments; and ultramarine, madder lake and some earth colours are transparent or semi-transparent pigments.

Talens indicates the opacity and resistance to fading of each colour on the package and the composition of the pigments is also given in the company's catalogue.

The following code is used to indicate the opacity:

opaque	■
semi-opaque	◪
semi-transparent	◨
transparent	☐

The code used to indicate the degree of resistance to fading is the same as that given under 'Watercolour paint'.

OIL PAINTING STICKS Oil painting sticks consist of compressed oil paint in stick form, housed in a sturdy sleeve. The slowly drying paint film on the point must be removed each time before use. This material can be used for both drawing and painting. The paint strokes can be worked with white spirit, turpentine or painting medium to create areas of colour. The sticks can also be used in combination with paste-like oil paint.

AUXILIARY MATERIALS Oil paint is applied to canvas, rigid supports such as wood, chipboard and hardboard and cardboard and paper, all of which must first be primed. Unprimed supports absorb too much oil from the paint.

Artists' canvas and paper can also be obtained ready-primed, and universal board is also a suitable support.

Artists' canvas can be purchased to length or ready-stretched on a stretcher. You can also stretch and prime the canvas yourself (see 'Mounting, stretching and priming').

The choice of brushes is dependent on the way in which the oil paint will be worked. If paste-like paint is used, stiff, hog's hair, round and flat Gussows are suitable, while for more fluid paint softer ox hair, polecat or filament brushes are suitable. For finer work and for glazing it is better to use quality red sable and Kolinsky hair brushes. Paste-like paint can also be worked with painting knives.

Oil painting palettes are flat and are made of wood, metal or plastic. Wooden palettes must be well varnished so that the wood cannot absorb the oil from the paint. Arrange the paint in a fixed order around the edge of the palette. This leaves sufficient space on the palette to mix colours. If you work indoors a sheet of thick glass or plastic is a good alternative.

For mixing large quantities of paint – which can damage brush hairs – a special palette knife is availabe. This knife is also used to transfer paint from the palette

to the support where it can be further worked with a brush or painting knife.

Palette knives are stiff, painting knives are supple and springy. A stiff palette knife should never be used on a flexible support because it can easily damage the surface.

Oil paint can be worked in its pure form or it can be made more fluid. For the first layers of a painting, the paint is thinned with white spirit or turpentine.

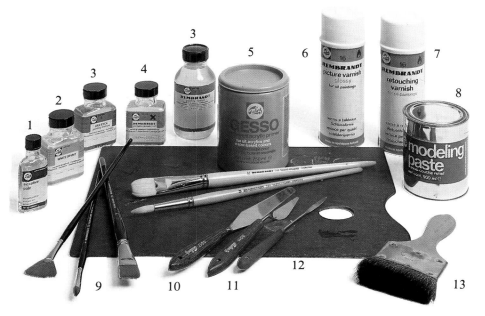

Auxiliary materials for oil paint

1 Siccative
2 White spirit
3 Painting medium
4 Varnish – matt
5 Universal primer
6 Aerosol varnish – glossy
7 Retouching varnish
8 Modelling paste
9 Soft- and stiff-haired brushes
10 Palette knife
11 Painting knives
12 Palette for use with paste-like paint
13 Spalter

This makes the paint less oily and therefore it adheres better to the surface of the support.

Painting in oils is based on the principle of 'oily over less oily', which means that after the first layers have been laid down, the white spirit and turpentine must be replaced by a more oily painting medium, a little more of which must be added for each layer.

There are many types of medium available – mediums that make the paint thinner of thicker, mediums that speed up or slow down the drying time, mediums that increase the transparency of the paint, and so on.

When you are painting, you may find that in places the paint soaks into the support and creates dull patches and this sometimes makes it difficult to determine the correct colours to use in the next layers. These patches can be painted over with retouching varnish, however. This restores the brightness of the colours and after a few hours you can continue painting.

There are three main techniques of painting in oils:
– Layered painting (opaque): a layer of opaque paint is laid down over a layer of opaque paint which has already dried.
– Glazing (transparent): A layer of well-thinned paint is laid down over a layer of well-thinned paint which has already dried. The upper layer does not conceal the layer under it, but creates optically mixed colours.
– Wet-in-wet technique: in the Alla Prima technique, which can be used with both paste-like and fluid paint, painting continues in wet layers of paint so that the colours mix.

Oil paintings must dry in an environment which is not too cold. The drying time can vary from six months to three years, depending on the thickness of the paint layer. A painting can only be given a layer of varnish when it is thoroughly dry. It is possible, however, to apply an intermediate varnish using retouching varnish when the top layer of paint is dry. This varnish does not form an impermeable layer so the paint underneath can continue to breathe.

Clean the mixing areas of the palette with white spirit. Wash brushes out in white spirit and then rinse them in lukewarm water. Clean the screw threads of your paint tubes, screw the tops on tightly and roll the tubes up as far as possible.

Store paints, mediums and varnishes in a cool place. At low temperatures mediums may become 'blind'. They can be restored to their original state, by leaving them to stand at room temperature for a few hours before use.

Always store your painting materials out of the reach of children.

APPLICATIONS AND MATERIAL TRIALS

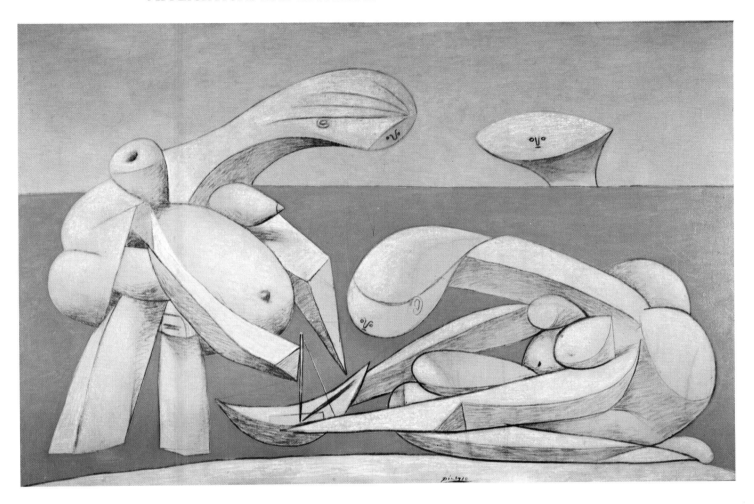

Bathing already exhibits facets of Picasso's later Surrealistic work while the bathers themselves betray his interest in sculpture – he began to make sculptures in about 1931. The feminine forms are represented in a distorted and almost excessively expressive way and the style is greatly at variance with the subject – women playing with a boat. The face on the horizon gives the sea an other-wordly atmosphere. This is emphasised because the blue plane of this sea appears to be vertical and the face seems to be peering over al wall. This effect, together with the size of the head, also reduces the effect of depth in the painting. The painting was executed on canvas in charcoal, white crayon and oil paint. The charcoal drawing, which was laid down directly on the bare canvas was left open so that the canvas gives the human figures their tone.

The areas of shadow were laid down scantily in charcoal hatching, while the highlights in the painting were laid down just as scantily in white crayon. This strengthens the expressive form still more. The blue of the sea and sky was laid down carefully and tautly in thin oil paint; although these areas appear to be even in tone, the canvas is still visible through the paint layers. This painting was in all probability given a layer of fixative not only to protect the work but also to promote good adhesion between the crayon, the charcoal and the support.

Bathing
– 1937
PABLO PICASSO

Beach
– 1986
PIETER MAN IN'T
VELD

Man in't Veld makes paintings with oil paint. primer and silver sand. (Silver sand is used in bird cages and can be bought in pet shops.) Landscapes have fascinated him since his youth and it is not surprising that they are often the subjects of his paintings. He finds his subjects in the countryside or – when he is drawn to a particular landscape which is inaccessible – in photographs.

First he makes sketches of his chosen landscape. His images are not true to nature, but abstract simplifications. Man in in't Veld works in planes of colour and therefore omits the details. How the various sand structures will be incorporated in the final painting is already partially determined in the sketches. The combination of colours to be used in the painting is also considered. He often works with a basic colour which he applies in many different nuances, adding a few colour accents. This painting is executed on fine linen canvas primed with a universal primer. (Oil paint and acrylic, as well as watercolour, can be used on such a primed support.) After the composition has been largely determined in graphite, the canvas is laid flat.

The primer (undercoat) is mixed with the sand to make a stiff but malleable paste which is laid down on the canvas with a painting knife.
This paste remains malleable enough to work on for an hour to an hour and a half. The structured painting must then be allowed to dry for at least twenty-four hours, after which it can be set in an upright position and painted.

Detail: this detail from the painting is a good illustration of the various structures laid down with the painting knife. When the paste was applied the areas were smoothed down and sometimes raised a little at the edges. There is an alternation between taut and rounded lines. The colours are toned down with white.
The paint was diluted with white spirit and applied sparsely on the sand-containing paint layer, by which it was thoroughly absorbed. When it was dry, painting continued using paste-like paint. Some areas of the first thin paint layer were retained. Soft-haired brushes were used for painting the sand structures.

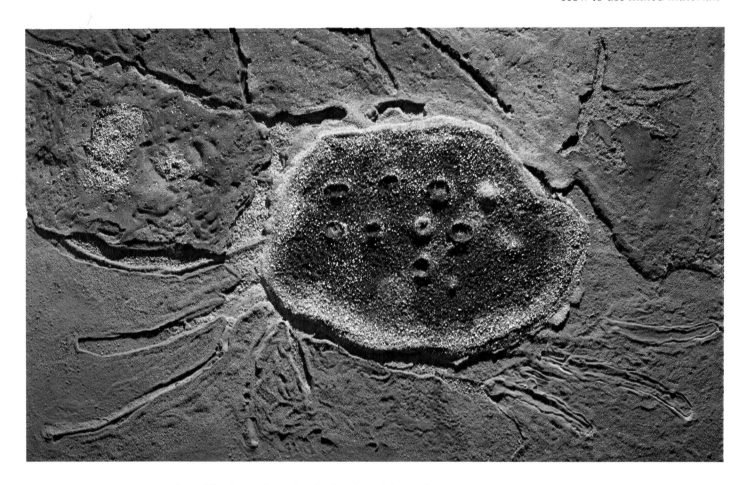

Parthélie
– 1967
JEAN PIAUBERT

Jean Piaubert also mixed oil paint with sand. The properties of the materials and his own fantasy allowed him to create strange land-scapes of burning earth and illuminated dark-ness. *Parthélie*, which means 'mock sun', is a clear example of this. The way the material is worked reminds us of the high water mark on the beach, where the ebbing tide has left be-hind all sorts of patterns in the sand.

In the top right of the picture the paint film is peeled back, as it were, revealing the underlying layer of sand. More sand was also sprinkled in the still-wet paint layer. The ad-hesive powers of oil paint are sufficient to bind the sand grains.

(A parhelion, or mock sun, is a bright spot at the same height as the sun. It is often clearly coloured, the red part turned towards the sun. The white tail, which is part of the parhelion ring, is turned away from the sun.)

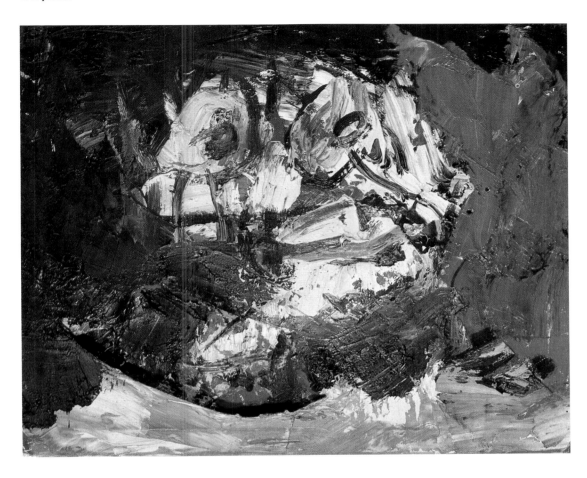

This painting contains two supports, one over the other. The upper support consists of linen canvas, the support under it is hardboard. There is a small space between the two supports.
An incision was made in the canvas which was then pushed back towards the hardboard. This adds an element of spaciousness to the painting and gives it something of a three dimensional effect. It emphasises the expression of the mouth of the carnivorous head and makes the gaping, all-devouring jaws the central feature of the painting.
The painting was made in oil paint and tempera. Tempera is an emulsion paint, which contains egg white and/or egg yolk, and after it has dried it is water resistant.
Before oil paints were discovered, in the middle of the 15th century, tempera was the best-known and most-used type of paint. It is still used – although in a limited way – for making underpaintings for oil paintings. Nowadays, however, it is usually replaced by acrylic paint.

Carnivorous Head
– 1965
JAN SIERHUIS

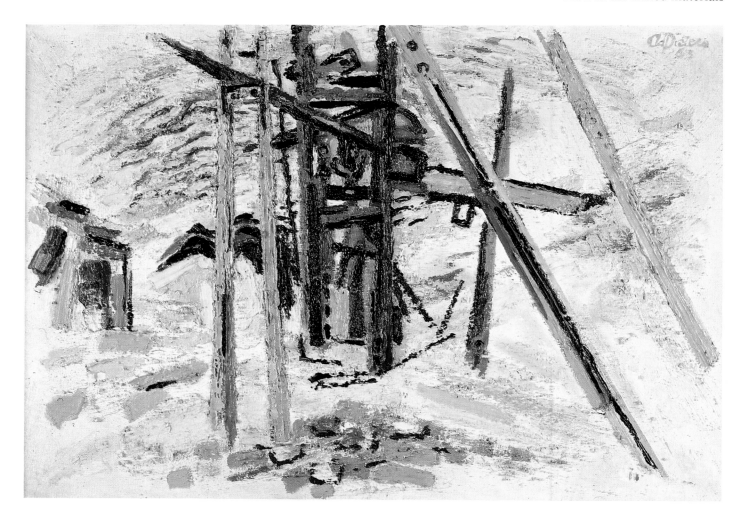

Ghost Mine
– 1963
AD PIETERS

The remains of mines dating from the days of the great Gold Rush at the end of the 19th century can still be found in Colorado. The mines have long been abandoned and all that remains is a tangle of broken beams and collapsed timbers with here and there barely reconisable bits of useless, rusting machinery. This work was painted on linen canvas which had been prepared with an oil-containing primer. In the last paint layers, burnt coal dust was worked into the oil paint so that the texture of the painting is as rough as the earth's crust in Colorado.

The composition of *Ghost Mine* was worked out in white and grey tones, thinly laid down in oil paint. A second, more oily layer was then laid down. Stiff-haired flat Gussows were used for this stage of the painting.

The fine ash was sieved out of the cinders in the ashpan of the stove in the studio. These cinders are to give volume and texture to the paint in the last layers of the painting. By increasing the volume of the paint it was possible to work in thick layers without risk of the paint cracking.

The cinders were mixed with white paint, which was tinted a little so that it would be visible against the layers of white paint already applied to the canvas. The mixture was then laid down in different layers using a palette knife. It was worked on further using a painting knife and stiff-haired brushes.

This is a layered painting and each layer therefore had to dry before the next layer could be applied. The vertical and diagonal beams were not structured but laid down in unthinned paint, sometimes applied directly from the tube after which a few more opaque touches of paint were laid down.

Oil paint

Detail: this detail from *Ghost Mine* shows the alternation between pure, opaque and structured paint. In some places well-diluted paint is washed in over light areas of colour.

Solidarity
– 1988
MARIET GIESBERTZ

Mariet Giesbertz received her training at an academy of applied art where she specialised in drawing and fashion.
Mariet used to work with newspaper and fabrics to make her creations, but she now builds them up in tissue paper which she paints in oils.
Solidarity is a result of this method of working.
Mariet Giesbertz decides the main colour of her piece of work beforehand. So that she can actually work with the chosen colour during the early phases, she uses tissue paper in that colour to build up the images. This technique requires a sturdy support and she has therefore chosen universal board.
The tissue paper is smeared with a thinned, synthetic resin-based size and then mounted on the support.
The image is built up from small pieces of paper and Mariet does not mind that the colouring agent runs out of the paper in an alarming fashion. When the required relief has been obtained, the sized paper must first be left for a few days to dry out thoroughly. Because of the synthetic resin size the paper becomes extremely hard. She then continues to work on the painting in oil.

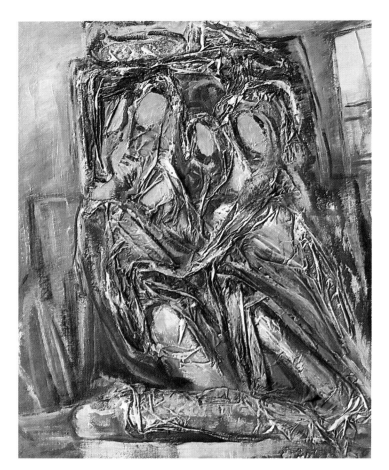

Detail: for the first stage the paint is very well thinned with medium and this creates transparency. In subsequent stages the paint is used thicker and is finally lightened whith white.
Because the work is not varnished, the contrast between glossy and matt areas of paint is evident, and this strengthens the effect of the relief.

Oil paint

Material trial **XV**
(Oil paint)

Further colours are created when the paint is
applied to layers which are still wet.

In layered painting a number of layers are laid
down one over the other, with a period of dry-
ing time between each layer. Opaque layers of
paint do not therefore mix together.

Glazing is also a layered painting technique
in which layers of transparent paint are laid
down one over the other. This creates
optically mixed colours.

Material trial XVI
(Oil paint and sand)

A textured paint can be created by mixing oil paint with sand, sawdust, grit and similar materials. The paint remains workable for between an hour and an hour and a half.

Material trial XVII
(Oil paint and modelling paste)

A structured underpainting can be laid down in modelling paste (Talens). This paste, which is applied to the support with a painting knife or stiff-haired brush, hardens, after which it can be painted over in oils.

Material trial XVIII
(Oil paint and paper relief)

Layers of relief are also created when structures in papier-maché or sized paper are laid down on the support before painting. You can do this with a suitable size or by attaching the material with modelling paste. The tissue paper structure in this illustration has not been completely painted over so that you can see it more easily.

ACRYLIC PAINT

COMPOSITION AND PROPERTIES Acrylic paint contains pure, finely-ground organic, inorganic or synthetic pigments of bright intensity.

The binding agent consists of acrylate resin, one of the few synthetic resins which is soluble in water. This means that acrylic is a type of paint which can be thinned down with water.

Besides pigments and acrylate resin, acrylic paint also contains additives to prevent mould and reject bacteria. Depending on the pigment it contains, a colour may also contain a certain percentage of thickening agent which gives the paint a good consistency. A frost resisting agent is also added.

Acrylic paint is darker in colour when dry than it is when wet. It is water-resistant once dry.

This material can be bought in tubes, tins and bottles. It dries quickly and it is therefore unwise to leave the container open unnecessarily. Hardened acrylic is no longer usable.

Not all acrylic colours have the same opacity. There are more opaque and semi-opaque colours than transparent and semi-transparent colours. Good quality acrylic paint has a high resistance to fading. The Talens company indicates opacity and the resistance to fading of each colour on the package and the catalogue also gives details of the pigment composition of each colour separately.

The following code is used for this:

+++ highest resistance to fading
++ good resistance to fading
+ low resistance to fading

■ opaque
◪ semi-opaque
◨ semi-transparent
☐ transparent

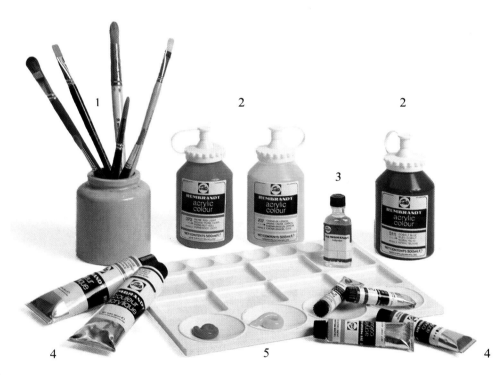

AUXILIARY MATERIALS Acrylic paint adheres to practically any support, as long as it is grease free and fairly absorbent. The suitability of the support depends on the painting technique to be used for a particular piece of work. It goes without saying that stiff, paste-like paint requires a sturdier support than thinned paint.

When working with acrylic paint it is not necessary to prime paper supports. Materials such as canvas, wood and cardboard, however, absorb too much of the binding agent from the paint and therefore must be first primed with a synthetic

1 Brushes made of natural hair and synthetic fibres
2 Bottles of acrylic paint
3 Retarding medium for acrylic paint
4 Tubes of acrylic
5 Palette

resin-based primer (gesso, for example). Oil-based primers are not suitable for acrylic paint because of the oil they contain. The type of primer used is not always known when you buy already primed canvas and it is therefore always better to provide an extra layer of gesso. It is better to be safe than sorry!

See the section, Priming, Mounting, Covering and Stretching, page 115.

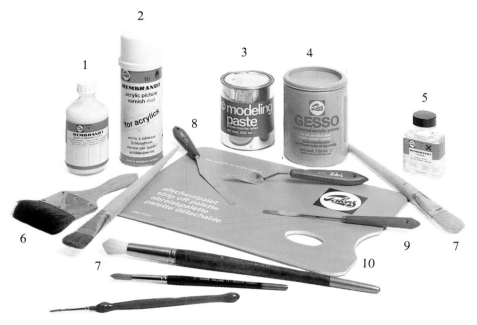

Auxiliary materials for acrylic paint
1 Acrylic medium – glossy
2 Acrylic varnish – matt
3 Modelling paste
4 Universal primer
5 Acrylic varnish
6 Spalter
7 Brushes made of natural hair and synthetic fibres
8 Palette knife
9 Painting knives
10 Strip-off palette

Both soft-haired and stiff-haired brushes can be used when working with acrylic. The choice of brush depends on the consistency of the paint, just as it does when working with oil paints. Bear in mind that acrylic dries very quickly and once dry can no longer be removed from the brush hairs. You must rinse your brushes in water frequently while you are working.

A flat palette or a palette with recesses can be used, depending on the thickness of the paint. A strip-off palette is handy when you are working outdoors. This consists of sheets of plasticised paper in the shape of a palette.

The sheets are gummed together at one edge and the block has a sturdy cardboard backing. After you have finished work the used sheet can be removed from the block and thrown away.

In its undiluted form, acrylic paint is paste-like and this means that it can be worked with a palette knife or a painting knife.

Acrylic can be thinned with water or with acrylic medium. Mediums which heighten and mediums which dull the glaze are available.

The glazing technique can be used with acrylic if it is diluted in the proportion of one part paint to four parts medium. In this technique transparent layers of paint are laid down over each other. Each layer must be completely dry before the next is applied. The advantage of using acrylic medium for this technique is that it increases the transparency of the paint.

Because layers of acrylic paint dry quickly, it is sometimes necessary to dampen the paint surface with a plant spray so that you can work on the paint a little longer. A special additive which slows the drying time of the paint is also available (for example Talens retarder). The addition of between two and five per cent retarder to the acrylic can delay drying by some twenty per cent.

Watercolour-like effects can be achieved with well-thinned acrylic and a retarder is often very useful when you are working in this way. Bear in mind, however, that layers of paint are no longer soluble once they have dried. While one can go on working endlessly, as it were, when painting in watercolours or gouache, this is not possible with acrylic.

Gel medium is a paste which can be added to acrylic in unlimited quantities without it affecting the colour and consistency of the paint.

If you wish to make textured paintings then you can lay down modelling paste on the support before painting it with acrylic. Extremely plastic layers are obtained in this way. The modelling paste

can be made more flexible by mixing it with approximately fifty per cent gel medium. Provided the drying time is taken into account, all the different techniques which can be used with oil paint can also be used with acrylic. The two types of paint are differently based and therefore require different auxiliary materials.

When you have finished work, wipe any traces of paint from the screw threads of the paint tubes and the rims of jars and bottles. Screw tops on tightly.

The palette must always be cleaned after use. Paint remnants harden and therefore cannot be saved. Scrape off old paint remnants and clean the palette with soap and water. Never use an oil-containing material such as white spirit for this purpose because acrylic paint should never come into contact with materials containing oil.

Clean your brushes, palette knives and painting knives. Rinse your brushes out thoroughly in lukewarm water and soft soap so that all traces of paint – especially those in the body of the brush near the ferrule – are removed from the hairs.

Acrylic paintings can be varnished. This is not always necessary, however, because acrylic is a water-resistant type of paint. When local differences in the gloss of a painting occur, varnishing may be necessary.

Varnishes are available in bottles and aerosol sprays.

Brushes used to apply acrylic varnish should be cleaned with white spirit and then rinsed thoroughly in water.

Store acrylic paint and auxiliary materials in a cool place. Acrylic paint which has frozen regains its original form and consistency when it thaws. Store pieces of work at room temperature.

APPLICATIONS AND MATERIALS TRIALS

Traffic Accident – 1963
JAN SIERHUIS

The first impression we receive from *Traffic Accident* is of a confused mass of wreckage with the oppressive feeling that blood has been spilt. This is precisely the atmosphere the artist wished to create when he made this emotional abstract painting. If we look further we discover the victim lying in the foreground. Jan Sierhuis used acrylic paint and paper to make this collage. The fact that he chose to use pages from a telephone directory was not without reason. They represent the medium of communication often thought of first when accidents happen. This piece of work was executed on a thick, cardboard-like type of paper which was not primed. The pages from the telephone directory were pasted down using a thinned synthetic-based primer (gesso) which, in effect, primed the reverse side of this paper. This will certainly increase the durability of the work.

Detail: Sierhuis began by laying down the red paint, over which he made the composition with the sheets of paper. Over this the black paint drawing was made and then filled out with blood red paint.

Flamenco
– 1988
JAN SIERHUIS

In *Flamenco* Jan
Sierhuis used the
Alla Prima technique.
The painting is made
with charcoal and
paint on primed can-
vas. First the flamenco
dancers were laid
down in spacious,
mobile lines using a
fairly thick stick of
charcoal. This drawing
was then fixed in order
to prevent loose parti-
cles of charcoal from
spreading or from
being taken up into the
paint layer. The layers
of paint were laid
down one over the
other without any
intermediate drying
time.
Sierhuis used the three
primary colours red,
yellow and blue to-
gether with black and
white as the basic
colours for this piece
of work.

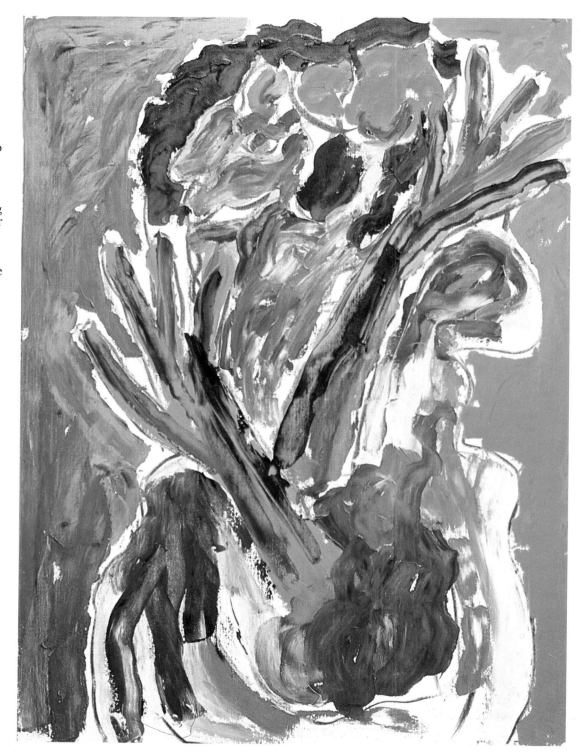

Acrylic paint

Detail: the artist did not work the entire can-
vas with charcoal and paint, but left areas un-
worked so that the tone of the canvas forms
part of the image.
The wet-in-wet technique resulted in mixed
colours being created on the canvas. The
heavy charcoal accents can easily be observed
in this detail. The mobility of the dancers har-
monises well with the fluid texture of the wet-
in-wet technique.

Material trial **XIX**
(Acrylic paint)

Wet acrylic paint appears much lighter than it actually is, due to the effect of the milky binder it contains.

This milky binder is colourless and transparent when it has dried and therefore dried layers of paint are darker in colour.

Like oil paint, acrylic paint can be applied in opaque layers, transparent layers or laid down in the wet-in-wet technique.

Acrylic paint

Material trial **XX**

Collages can be fixed
in various ways. Fairly
heavy objects adhere
well in a thick layer of
modelling paste.

Light materials can be
directly fixed in a fair-
ly paste-like layer of
paint or with painting
medium. Always use a
medium intended for
the type of paint you
are using.

AN ARTIST AT WORK

(Acrylic paint, charcoal, sandpaper and lead)

Lenie Aardse's work, which is largely executed in acrylic paint, charcoal, sandpaper and sheet lead, is abstract in nature although figurative forms are used as its basis.

Her paintings have something of the landscape and at the same time a certain corporeality. This will be made clear in the different phases of this piece of work and in the series of six paintings which follow it.

Preliminary study for
Estuaria
– 1988
LENIE AARDSE

I The painting is executed on a canvas primed with universal primer. The outlines of the composition are indicated in charcoal and filled out with pieces of sheet lead (the material used to seal the tops of wine bottles) and sandpaper. The sheet lead is ironed smooth and the sandpaper tinted slightly by rubbing it over a layer of acrylic paint. This breaks up its

texture to some extent and the grainy surface picks up particles of paint. During this lengthy process of arranging, removing and re-adding material, the canvas is lying flat on the ground.

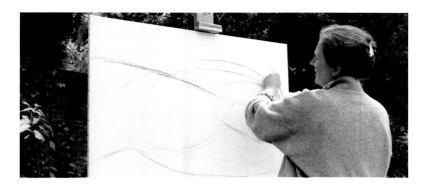

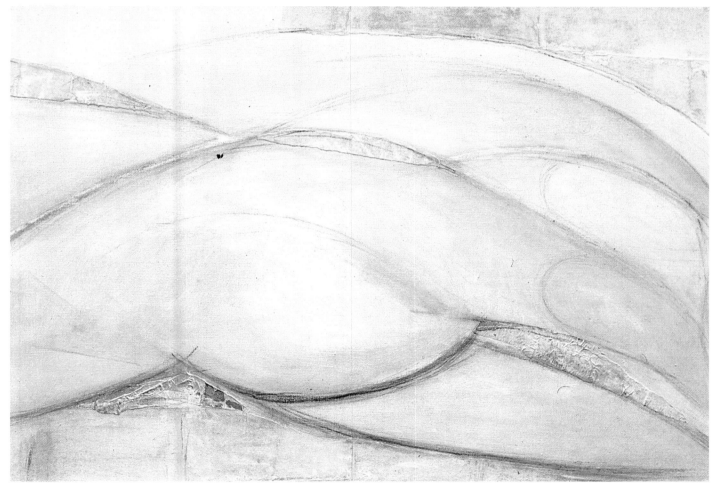

II The various components of the picture are stuck down with a mixture of universal primer and acrylic medium and must stand for an hour under pressure in order to ensure adhesion. The artist supports the back of the canvas in order to prevent it sagging and places a number of heavy objects on top of the components to provide the necessary pressure.

After an hour it is possible to continue work on the painting and the first areas of thinned, ochre-coloured acrylic paint are laid down.

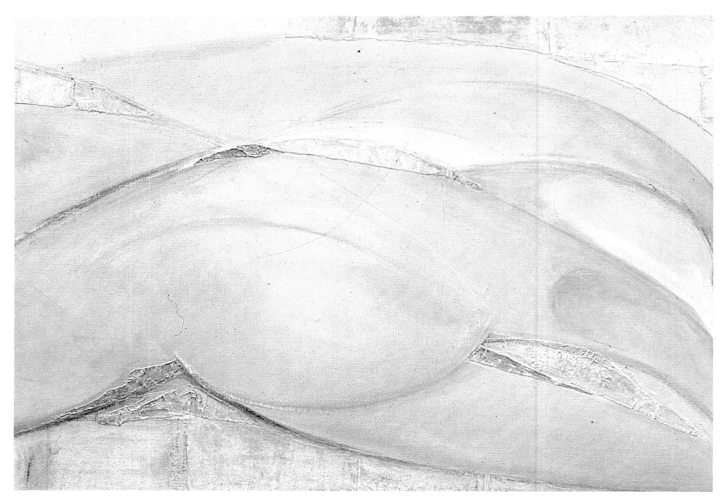

III After the acrylic has dried, it is rubbed down with fine sandpaper so that the texture of the canvas remains visible. The sandpaper will be used in one of her later works. The areas of sandpaper are now worked on with acrylic, and their texture and colour becomes more interesting. They become more a part of the image as a whole. The areas of paint are strengthened and sandpapered again, and the charcoal lines are also strengthened. The charcoal is not fixed but allowed to seep into the paint in order to give the shapes plasticity. Some areas of sheet lead are filled out a little so that they become more emphatic.

IV The acrylic medium between the canvas and the sandpaper and sheet lead creates a slightly raised edge. The non-paint related materials are taken up into the paint film, so changing·its structure.

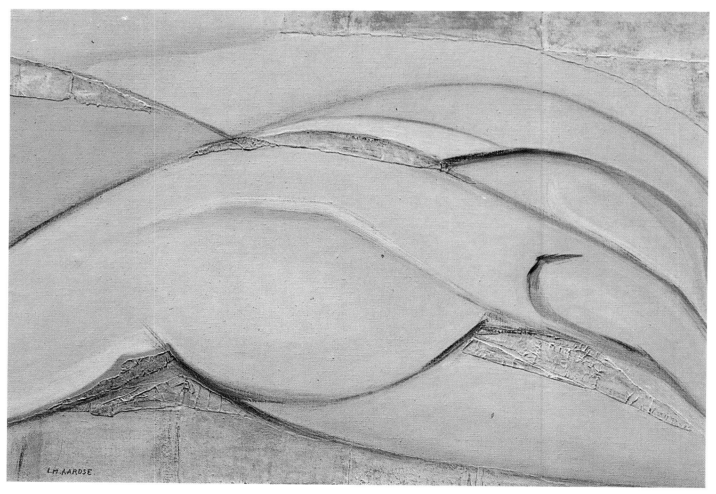

V A limited number of colours, applied in various intensities and tones, are used in this painting, intended as a preliminary study to the six-part painting *Estuaria*. The colours are soft and faint and provide a lovely counter balance to the sharp, silver-coloured sheet lead.

VI *Detail*: here the sheet is filled out with aluminium paint which heightens the effect of plasticity. In this detail you can also see how the texture of the canvas has remained visible.

Estuaria
– 1988
LENIE AARDSE

An estuary is a river mouth which is funnel-shaped due to the action of the sea flowing into it. There are usually sandbanks on both the land and the sea sides, built up of sediment deposited when the tide, under the influence of the earth's rotation, changes direction twice a day.

Lenie Aardse's plan was to use the preliminary study as the basis for a double triptych of paintings. These were begun during the making of the preliminary study. Each of the six elements measures 100 x 70 cm. Changes in the composition would take place because of the enlargement from the preliminary study to the eventual canvasses, so the initial conception was not followed definitively.

It was Lenie's intention to compose the six paintings in such a way that they would form a whole, but with the understanding that each canvas could stand independently as a balanced and absorbing fully-fledged painting.

The corporeal shapes mentioned earlier are perceptible in *Estuaria*, but the artist has deliberately chosen to make the landscape abstract so it is possible to change the order of the six canvasses.

Here, the long, outer edges of the canvasses are laid next to each other and the whole still retains its landscape-like atmosphere.

If the canvasses are rotated through 90° as shown opposite, one sees that the corporeal element moves into the foreground and the landscape element is suppressed. This kind of possibility interests Lenie Aardse deeply and she regards it as a new theme in her work.

Acrylic paint

COLLAGE TECHNIQUES

INTRODUCTION The collage technique is one in which the image is wholly or partially constructed from existing materials or from materials the artist has himself prepared and it allows him to operate outside the limitations of reality.

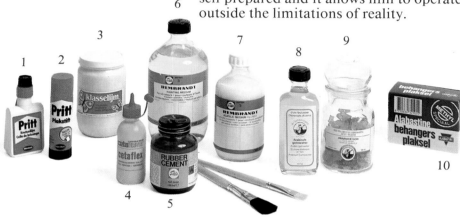

Binding agents I

1 Hobby glue
2 Adhesive stick
3 Adhesive paste – dextrine
4 Wood glue – synthetic resin
5 Photographer's glue (removable)
6 Painting medium (oil paint)
7 Acrylic medium – glossy
8 Gum arabic
9 Gum arabic piece
10 Methyl-cellulose

The basic idea of the collage technique – made popular by Robert Rauschenberg and Jasper Johns during the sixties – was actually used in ancient China, where traditional images were clipped and cut from transparent paper, and later from postage stamps, banknotes and illustrations.

The work of the 20th-century Surrealists in particular clearly shows that they used collages to give expression to their rich imagination, but in their later work Piet Mondriaan and Henri Matisse also made abstract collages from coloured paper, thereby disproving the frequently expressed allegation that artists worked with collage techniques in protest against abstract Surrealism.

There was another art movement which deeply concerned itself with collage techniques – Pop-art.

In contrast to abstract Surrealism, the Pop-art artists concerned themselves with reality and produced figurative art.

Their inspiration was fuelled by the refuse of the consumer society. Materials such as printed packaging, soft drink cans, magazines and other everyday objects were incorporated into their collages.

Pop-art is often regarded as an American art form, and there are a large number of well-known American Pop-art artists – Robert Rauschenberg, Jasper Johns, Larry Rivers, Roy Lichtenstein, Andy Warhol and James Rosenquist, to name but a few.

However Pop-art is a truly international art movement. Think of the French painter Martial Raysse, the British painter Richard Hamilton, and the Austrian painter Raoul Hausmann.

The realistic expression of the sixties has hardly been influenced and we can safely assume that the super-realism of the seventies owes its origins to Pop-art in particular.

Making a good collage makes great demands on the artist. He must take into account the fixed shapes which occur in different materials and the fact that each of these will create a different effect. Furthermore the materials must be firmly fixed to the support. An adequate knowledge of the materials and a degree of technical insight is necessary to do this. This subject is discussed in the section 'The adhesion of non-paint-related materials', page 98.

APPLICATIONS AND MATERIAL TRIALS

This Chinese cut-out is executed on silk. The subject 'Women sewing a cloak for their husband in the army' is traditional in design. The image is clipped and cut from stamps, banknotes and magazines – a form of recycling!

Detail: the light in the folds of the clothing was created by cutting the paper away so that the silk becomes visible. The cut-out is briefly filled out with black and white Indian (Chinese) ink. The artist is unknown, but the period when this cut-out was made can be more or less determined by the materials which were used.

A Chinese cut-out – beginning of the 20th century Artist unknown

Zulma
– 1950
Henri Matisse

Henri Matisse began
to make his impressive
series *Gouaches
découpées* late in life.
He cut his images out
of paper coloured with
gouache. Matisse had a
lot of pain (he suffered
from arthritis) but his
work is cheerful: the
high-spirited, bright
colouration is striking.
Although Matisse nev-
er concerned himself
with sculpture, he
nonetheless spoke of
the three-dimensional
effect of his cut-outs.
'Cutting in living col-
our reminds me of a
sculptor's carving'.

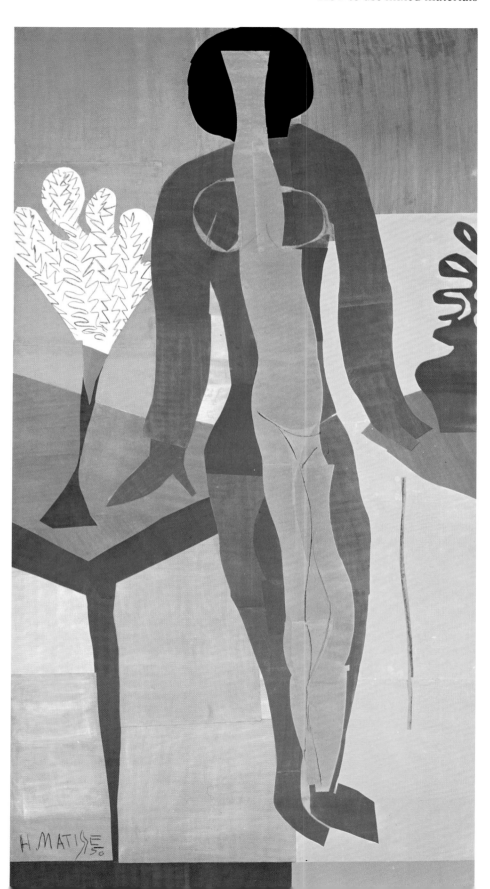

86

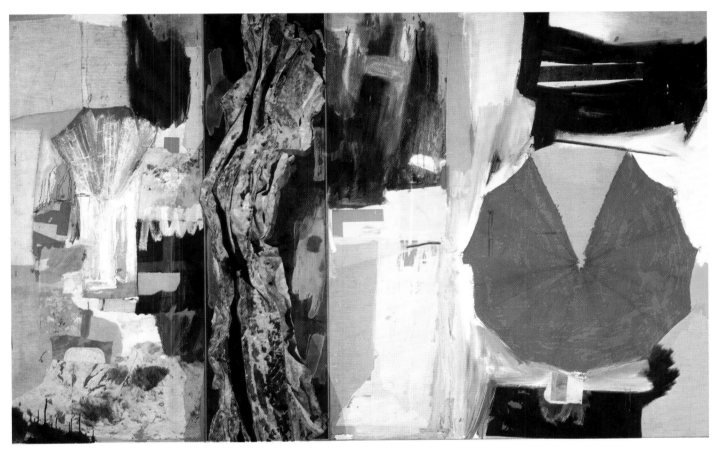

Rauschenberg produced three-dimensional objects under the motto 'Painting has a relationship both to art and to life'. *Allegory* is a combined painting and contains both artistic elements and objects from everyday life. By using paint to isolate – or to integrate – his objects, Rauschenberg retains the traditional conceptions of painting.

Allegory
– 1959/60
ROBERT RAUSCHEN-
BERG

Bottles in the Window
– 1987
ALAN BROWN

Alan Brown assembles his pieces of work entirely from white, black and coloured paper. He cuts out his shapes with a razor sharp lancet and uses photographer's glue to attach them on his support.
Bottles in the Window is a decorative piece of work. Brown's use of colour is both sophisticated and daring. The degree of resistance to fading of the various types of paper is very important in this technique.

Collage techniques

Central Station
– 1987
ALAN BROWN

Brown was impressed with Amsterdam and assembled a large piece of work in which old and new architectural styles go hand in hand. He considers the consequences of living in the centre of a large city to be important, and symbolises this in the form of a group of policemen. A little white paint is used to indicate the sculpture on the walls of the station.

Detail: in his paper collages Alan Brown uses a very old technique. It is based on a textile technique which the American Indians applied in making articles of clothing. This consists of making use of a number of layers of material in which areas are cut away so that the underlying layers can be seen through those over them. The different coloured layers of material together form a single image. The work, entitled *Central Station* is clearly influenced by Pop-art.

My Son's Shirt
– 1965
JAN SIERHUIS

Because an article of clothing would be incorporated in his painting, Sierhuis started with a pure canvas which he pre-sized in order to make it stiffer and more tensioned. This made the canvas less liable to stretch. In order to prime the canvas, Sierhuis prepared a primer consisting of 1 part rabbit glue (50 grams in 1 litre water), 1 part zinc white, 1 part chalk and 1 part boiled linseed oil. (The quantity of linseed oil depends on the absorbent properties of the canvas to be used and can vary from 1 to 10 parts.) The oil paint was laid down with brush and painting knife. This is scanty in the first layers, but used more and more paste-like in later layers. These paste-like paint layers made it possible to press the child's shirt into the still-wet paint so that it was not necessary to use size. In order to bring balance into the composition, the green colour of the shirt was brought about by applying a piece of green linen. Only red, yellow, white and black paint are used in the painting.

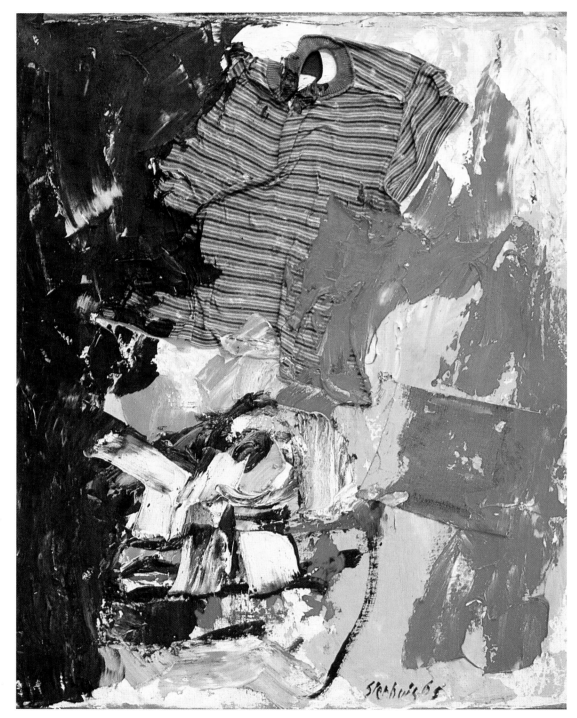

Detail: additional accents of colour are laid down over the shirt. Although the painting contains thick layers of paint, these are laid down in phases, so that no cracks can appear. The build up of these layers can be seen in the bottom right of this area of paint, where yellow paint is laid down over white. The layer of red paint also lies partially over this.

*Dead Material Does
Not Exist
– 1986*
LIES CORTEL

The title of this painting indicates what Lies Cortel thinks about using non-paint-related materials in her work. During a conversation with her she suggested that paint is by no means the only method of expressing the structure of a material, but that concrete materials can create a certain tension in a composition. 'Every material has a different temperament', she says. But she is not afraid to apply paint to parts of her compositions if extra colour or texture is required.

Linen, black sandpaper, cardboard, zinc, copper and cement are worked into this composition.

She was dissatisfied with the grain of the wood and therefore paint has been used to give it a different texture. The elements are attached to the linen canvas with wood and metal glue.

Because some of the metal plates are positioned at the edge of the canvas, they are supported by the underlying stretcher bars. Light materials are worked into the upper part of the painting so that the weight of the material is spread over the whole canvas. This means that the canvas cannot stretch.

Material trial **XXI**
(Paper collage – Mola technique)

Use coloured paper, or paint paper with
gouache or acrylic, for this technique, as the
resistance to fading is then much higher.
The mola technique is set out in four phases
in the illustration. Try to execute some
arbitrary subject using this technique, indicat-
ing the areas of light and shadow in a way
which is as clearly visible as it is in the detail
from *Central Station*.

AN ARTIST AT WORK

(Collage: oil paint and non-paint-related materials)

'Look, this is my material,' says the eighty-year-old Lies Cortel, as she empties a plastic bag at our feet. We have asked her permission to photograph the various phases in the creation of one of her pieces of work.

Blocks of wood and battens from the attic, bits of stone she has brought back with her from holiday because she found them so beautiful, and all sorts of other bits of material which she might be able to use, lie spread over the floor.

Lies Cortel is self-taught. Those who study her work can visualise her long life, dominated by an inherent urge to create.

I This piece of work is executed on canvas board. To a large extent Lies Cortel can visualise the image she wants to create. A brief sketch is all that she needs to indicate the outlines of her composition. Her chosen subjects betray her deep social conscience. This time her theme is 'the social ladder' which can only be climbed with great perseverance and acquired knowledge. As a symbol of this she positions a sort of settlement high up on a mountain by grouping three wooden triangles which are attached to the support with modelling paste. The first brushstrokes follow only an hour later.

II In this phase Lies Cortel is mainly concerned with the right-hand side of the painting. The placing of the wooden ladder against the side of the high mountain emphasises the effort one must exert in order to reach one's goals.
The ladder is attached with modelling paste, and the canvas is laid flat in this phase in order to prevent the ladder 'sinking'.

III To the left of the ladder an enormous pile of books reaches high into the picture and symbolises 'wisdom' in all its forms. In contrast to the right-hand side of the painting, the paint here is thinned with painting medium and laid down opaquely. The many mixed tints are very close to each other. Lies Cortel often takes the paint directly onto the brush from the tube. Sometimes she mixes the paint between her fingers and rubs in an area of paint with her finger.

Detail: the non-paint-related material makes the work three-dimensional. This detail shows that the artist has worked in small touches of paint. The rungs of the ladder and the roofs have the same rhythm.

Detail: the books are indicated in areas of colour with a few lines worked into it, and they form a good contrast with the plastic form of the ladder which tends to relegate them to the background of the painting.

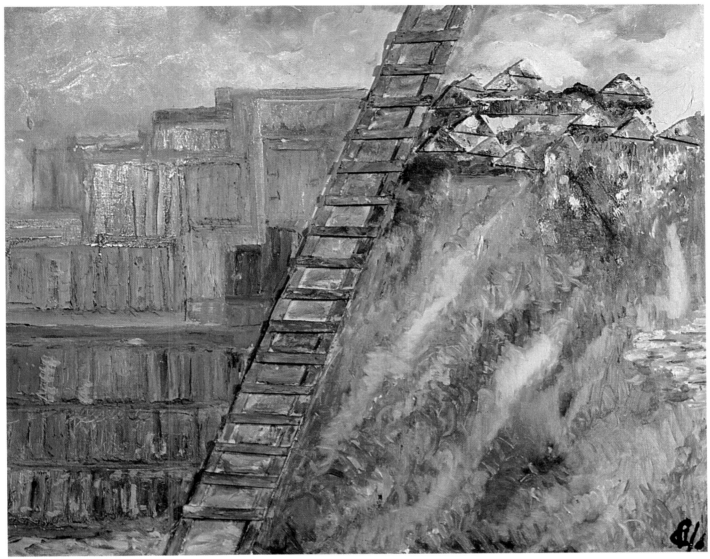

The Social Ladder
– 1988
LIES CORTEL

IV After four sittings the painting is completed (a sitting is the length of time for which the artist works uninterruptedly). The paint must dry between these sittings. The painting has a great effect of depth, provided by the high mountain and the receding ladder in the foreground, and the huge pile of books, which are reminiscent of tall apartment blocks, in the background. This heightens the landscape-like effect.

NON-PAINT-RELATED MATERIALS

VARIOUS APPLICATIONS In the previous pages examples have been given of pieces of work in which mixed techniques have been applied. The following techniques have been described:

- combining drawing materials
- thickening paint with non-paint-related materials
- the use of a non-paint-related material as an addition to a painting executed in paint, in which the non-paint-related materials are given form.
- the use of a non-paint-related material as an addition to a painting executed in paint, in which the non-paint-related materials retain their original form
- the use in a painting of objects which retain their original form and in which the paint plays a very subordinate role.

When working with non-paint-related materials one quickly discovers that they offer a wide variety of working opportunities. This chapter discusses pieces of work in which non-paint-related materials are used exclusively or in which they play the main role.

THE ADHESION OF NON-PAINT-RELATED MATERIALS When using non-paint-related materials in your work the first thing to remember is that paints often contain sufficient binding agents to fix these materials if they are pressed into wet paint layers.

This obviously depends on the paint's consistency and the binding agent it contains. In wet watercolour paint, for example, which contains gum arabic as a binder, and which is applied very thinly, only tissue paper and silk paper at the most can adhere; in gouache, which contains gum arabic and dextrin, only thin types of paper and textiles will adhere. In paste-like oil and acrylic paint layers, which contain oils and synthetic resins and which can be applied thickly, heavier materials such as cardboard, thin metal, wood, thicker textiles and similar materials will adhere.

In addition, the corresponding mediums also form good binding agents. These contain those adhesive materials which must bind the pigments and must also ensure that the paint adheres to the support.

Primers, painting and modelling pastes and gel medium can also be considered. Modelling paste laid down in a thick layer has such adhesive powers that heavier objects such as stone, wood, metal, bits of plastic, glass and similar materials stick to it easily. You must bear in mind, however, that this white paste retains its white colour when dry and generally speaking must be painted. This is also the case with gesso and painting paste, but gel medium is almost colourless and transparent when dry.

It may also be necessary to use an adhesive medium other than paint or these various painting mediums – in laying down collages within drawings or paintings in which the paint is used very thinly, for example. As a rule you must, whenever possible, use a type of adhesive which corresponds to the binding agent in the material you are using. In other words, gum arabic for watercolour, gum arabic with dextrin for gouache and a synthetic resin-based adhesive for acrylic.

Oil-containing adhesives do not exist but wood glue (made from animal bones) and synthetic resin-based adhesives yield excellent results when used in combination with oil paints.

Composition
– 1987
HENK ERKELENS

Henk Erkelens 'builds' his paintings using various types of clay such as kaolin, pipe clay, raw clay and loam which he makes himself. He works these materials, filled out with silver sand and ground brick, into large relief paintings. He has experimented widely with these materials with the aim of making abstract clay paintings. This photograph shows a painting which he made in 1987.

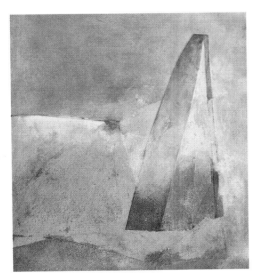

Abstract Material Painting
– 1988
HENK ERKELENS

Erkelens used a hard type of hardboard as his support. He primed this with universal primer and then sanded it down. He used synthetic materials, including acrylic medium, as binders, and this means that the materials are extremely hard and can quite happily survive out of doors. Wind and weather have no effect on them.

Henk Erkelens first covered the panel with a ground of clay mixed with sand, laying down the forms with a palette knife. He does not like coincidental effects in his work. Because he has experimented so widely he knows how the materials react and can work this out beforehand. He decides where the craquelure (cracking) effects, created by the shrinkage of the material, will be and can create a good composition intuitively.

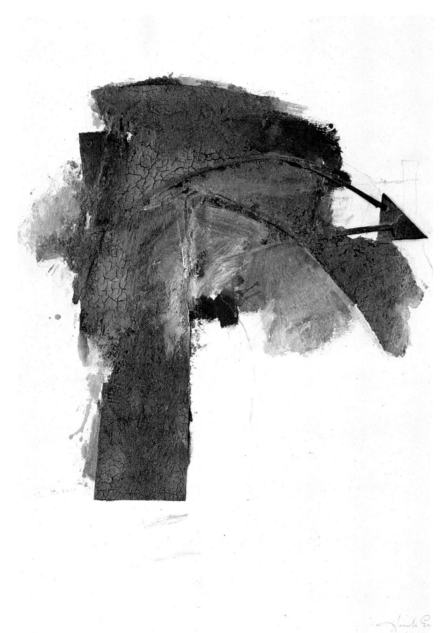

*Abstract Material
Painting II
– 1988
HENK ERKELENS*

Although one would think that this method
of working can only be done on sturdy
supports, the series of preliminary studies
Erkelens makes for his large paintings are
actually executed on unprimed paper.

Abstract Material Painting II is an example
of this. The colour is largely determined by
the colour of the materials he is working with.

Detail: additional tones are washed in with
thinned acrylic paint. He chooses colours
such as ochre, sienna, burnt umber and
Naples yellow, filled out with cobalts and
ultramarine, ensuring that the colour is never
emphatic. Erkelens' paintings are contempo-
rary, but they give a strong impression of
ancient bygone days.

Good adhesion can best be achieved if you glue both the surfaces which are to be joined, allow the adhesive to dry a little and then press the two surfaces together. An exception to this is 'instant glue' in which the two surfaces must be pressed together immediately because the glue hardens very rapidly.

TYPES OF ADHESIVE

Gum arabic Gum arabic is obtained from certain acacia trees. The bark dries, cracks and then bleeds drops of gum arabic.

Gum arabic is obtainable in various forms – as pellets of dried gum, as a syrupy, liquid adhesive and as size. It is yellowish in appearance but when dry it is clear and transparent.

Brushes used with gum arabic can be rinsed in lukewarm water, even after the gum has dried. Paper adhesive tape used to stretch aquarelle paper contains a layer of gum arabic. If this is moistened with water the gum arabic dissolves and regains its opacity.

Dextrin This is also a natural product and is prepared from starch. It is a semi-transparent, white adhesive which dries practically colourless. Dextrin is subject to deterioration and therefore contains a preserving agent. A few drops of lysol or creosote can also be added. Brushes can be rinsed in lukewarm water, even after the adhesive has dried.

Cellulose adhesive Cellulose is a vegetable product obtained from the cell wall of plants. This adhesive is usually available in powder form and must be dissolved in water. It is then transparent and has good powers of adhesion. Cellulose is not liable to deterioration and can be used for glueing paper, light cardboard and thin textiles.

Brushes can be rinsed in lukewarm water, even after the adhesive has dried.

Photographer's glue (rubber cement)
This adhesive contains rubbery materials dissolved in a fluid and is not always absolutely safe to use. Where some brands contain non-toxic materials such as benzol and toluene, others contain the highly dangerous material ketone (for example Foto Mount from Scotch).

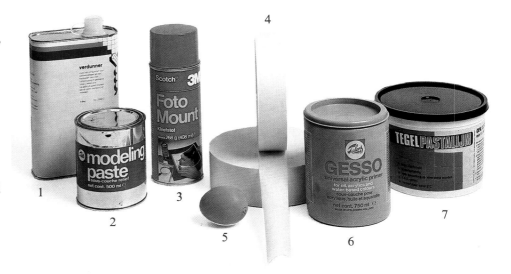

Avoid breathing in the fumes. Photographer's glue is acid-free and is intended to temporarily fix light materials.

Materials can be loosened so that it is possible to move them about while making a composition.

This material is colourless and transparent. Do not use brushes with photographer's glue but rather a strip of cardboard, or something similar, which can be thrown away after use. (This is because the adhesive can only be dissolved in acetone or benzene, but these materials are highly inflammable and should be avoided.)

Photographer's glue is inflammable. Keep it in a cool place, out of the reach of children.

Binding agents II

1 Thinner for various types of adhesive
2 Modelling paste
3 Photographer's glue
4 Acid-free paper adhesive paper
5 Egg (egg white)
6 Universal primer
7 Tile adhesive

Mixed Materials
– 1977
LENIE AARDSE

This piece of work
was executed on a
linen canvas.
The composition
was assembled from
gauze, linen and cot-
ton. The way in which
the canvas is divided
up was decided be-
forehand by sewing
the various materials
together. The power of
the painting, however,
was only created when
the textile composition
was stretched on the
canvas with gel
medium. Gel medium
dries slowly and so the
artist had sufficient
time to determine the
form of the composi-
tion.
The colour tones, for
which acrylic paint
thinned with water
was used, were washed
in by hand before the
textile composition
had dried out.

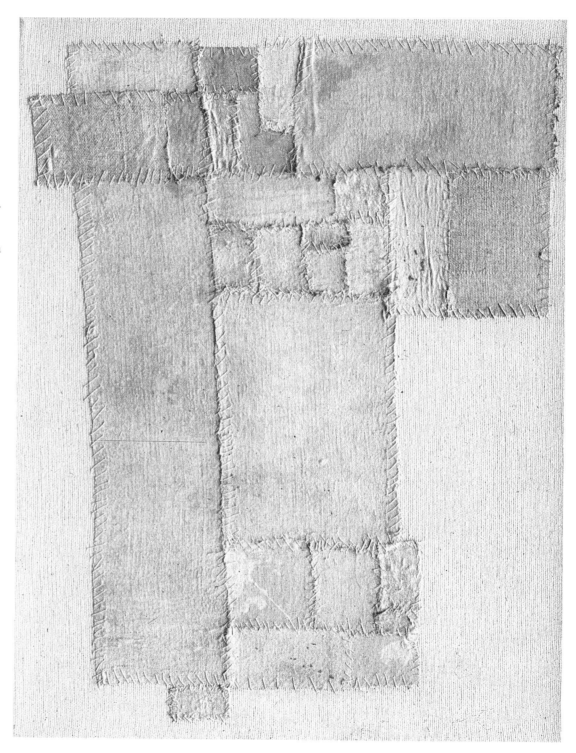

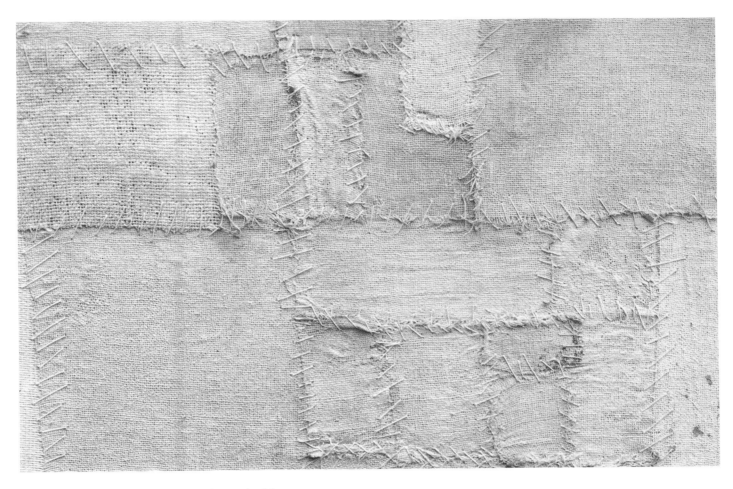

Detail: additional acrylic was again worked in by hand. This was done by exerting pressure until the textile had firmly adhered to the support. When the composition was completely dry, further accents of colour could be applied. The pieces of material are placed rhythmically and alternately.

Wood glue Natural wood glue is prepared from animal bones and is available in the form of solid pellets or sheets. Before use it must be heated in a bain-marie to form a syrupy liquid. This dark brown, transparent glue is applied while it is warm and hardens on cooling. Do not allow brushes to harden and wash them in hot water.

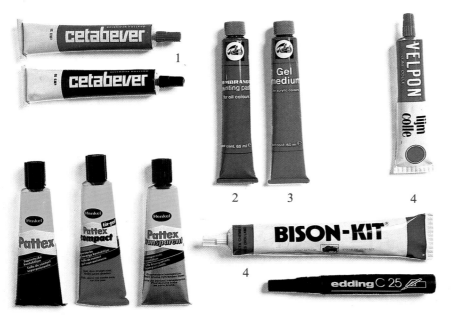

Binding agents III

1 Epoxy resin adhesive
2 Painting paste
3 Gel medium
4 Various types of contact adhesive

Synthetic resin adhesive Synthetic resin adhesive has synthetic resin as its basic material. In its liquid form it is white but when it dries it is almost colourless and transparent.

This adhesive is intended for glueing paper, cardboard and wood, but can also be used for attaching many other materials such as textiles, plastic and light metal sheets. This means that synthetic resin adhesive is a universal type of adhesive. Do not allow brushes to dry and rinse them in lukewarm water.

Special types of adhesive There are various types of adhesive intended for pieces of work which will mainly consist of heavy collage materials. These include iron cement, textile glue, tile cement, glues for PVC, polystyrene, cork, glass, plastic and other suchlike materials. You can also buy instant glue, which dries in a few seconds, and epoxy resin, which comes in two tubes, one containing the binding agent and the other the hardener. These must be mixed together before use.

Whichever type of adhesive you choose, always follow the instructions carefully. Bear in mind that many of these adhesives are inflammable and contain toxic materials. Do not use adhesive near a naked flame, and make sure that your working area is well ventilated. If the top is stuck on an adhesive container, then loosen it by soaking it in hot water. Under no circumstances use a match or cigarette lighter to loosen hardened adhesive. Keep adhesives out of the reach of children and store them in a cool, frost-free place.

AUXILIARY MATERIALS The following descriptions of the purpose and composition of various auxiliary materials is based on the products manufactured by Talens-Holland.

Designer's colour medium Improves the adhesion between paint and support. Makes the paint slightly glossy and reduces its opacity. Thinnable with water. Clean brushes in water.

White spirit Petroleum distillation product. Completely volatile (evaporates slightly faster than turpentine).

For reducing the consistency of oil paint and oil-containing types of chalk and for cleaning working materials containing oil.

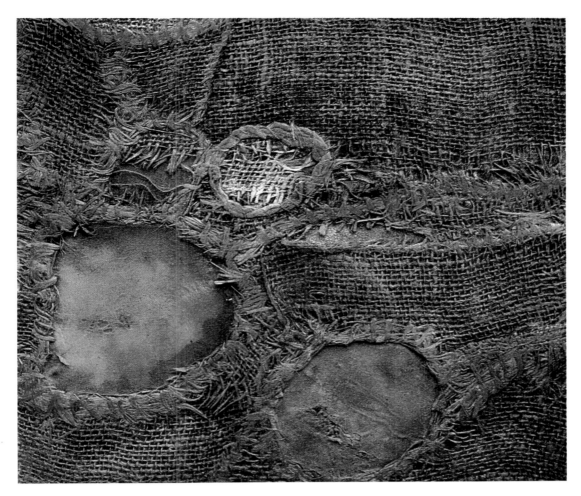

Mixed Materials
– 1976
LENIE AARDSE

The design of this textile composition is completely different. It contains rough woven jute, plaited jute fibres and a piece of nylon from a pair of tights. The whole was filled out with a little acrylic paint. The unusual thing about this piece of work is that it is not mounted – the jute itself, primed with acrylic medium, is the support.

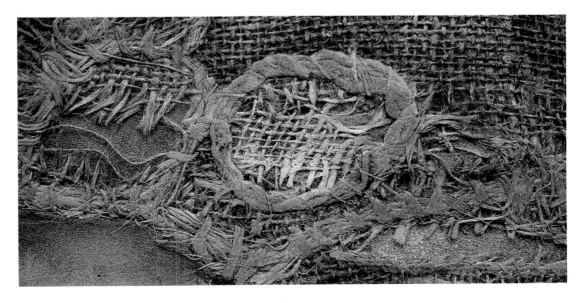

Detail: the colour in the weave was applied to accentuate the colour nuances of the different fabrics used and was also intended to protect the fibres.

A light, silvery film was applied to give the material fluorescence. This gives an unusual effect when light shines on it because the open texture of the jute has a distinct light/dark marking while the nylon spreads a more diffuse light.

Turpentine Product distilled from the pitch of pine trees. Volatile. It makes the paint leaner (less thick). Turpentine is also used to thin oil paint and oil-containing types of chalk.
Painting medium for oil paint, vegetable oils and non-yellowing synthetic resins dissolved in turpentine, etc. There are mediums which enhance or reduce the gloss of the paint and mediums which shorten the drying time. Siccatives have been added to the quick-drying medium. The mediums improve adhesion to underlying layers and extend the durability of the paint layer.
 Clean brushes and other working materials with white spirit or turpentine.

Painting paste for oil paint Vegetable oils, synthetic resins and thickening agent. Prevents wrinkling if paint is applied in thick layers. Shortens the drying time of the paint. Painting paste slightly reduces the gloss. Proportion painting paste-paint should be minimally 1:1.

Acrylic medium Based on an acrylate resin dispersion. It is a milky white medium which is transparent and water-resistant when dry. Available in both mat and glossy finishes. It is used as a thinning agent for acrylic paint and 'heightens' or 'flattens' the paint, depending on the nature of the material being painted. Wash brushes immediately in water; after the medium has dried it can only be removed with acetone or a similar material.

Gel medium for acrylic paint This acrylic paint medium has acrylate resin dispersions and thickening agents as its base. The milky, paste-like medium is transparent when dry. It makes the colour more transparent and more glossy and causes hardly any change in the consistency of the paint. Wash brushes immediately in water; after the medium has dried it can only be removed with acetone or a similar material.

Retarder for acrylic paint This retarder has slowly-evaporating thinning agents as its base. It is transparent and colourless. By adding a maximum of 2½ per cent to acrylic paint its drying time can be extended by 20 per cent. Clean the brushes in water.

Modelling paste This paste consists of a white, pigmented synthetic dispersion and is used to apply relief to surfaces. Depending on its thickness when applied, modelling paste dries within a few minutes or a few hours and creates an elastic surface. It can be used for paintings in oil and in acrylic paint. Gel medium can be added to make the paste more flexible. Modelling paste hardens quickly; wash your working materials in water immediately after use.

Primer (Gesso) Gesso is a universal primer and consists of strongly pigmented acrylate resin dispersions. It is suitable for priming all types of support which can then be worked with all types of materials. Thinnable with water. Brushes and painting knives should be washed immediately after use.

Ox gall Nowadays ox gall is prepared synthetically. It is a surface-active substance dissolved in water. Ox gall is used for degreasing surfaces. It can also be added in small amounts to the paint itself, which prevents it from 'beading' or 'pearling'.

Retouching varnish Non-yellowing synthetic resin (cyclohexanone) dissolved in turpentine, etc. This provisional varnish dries within a few hours and can be overpainted immediately. It is colourless and gives a low gloss. It can also be used as a final varnish for oil paint layers which are not completely dry. Clean brushes and other working materials with turpentine or white spirit.

Varnish for oil pastels Synthetic dispersion in water, with built-in surface agent.

Nail Relief
– 1930
GÜNTHER UECKER

Finally, there is also the possibility of creating artistically-sound pieces of work using only non-paint-materials, as can be seen in *Nail Relief* by Günther Uecker. Neither paint nor drawing materials were used in this. Nonetheless, the artist was able to create an intriguing work of art, a work that is not only animated but which also arouses our curiosity. Uecker's conception makes one consider the fact that paint and crayon are not the only materials in the world and that there are so many other ways in which to make worthwhile visual works of art. These works of art do not always need to be original in concept. Adapting old techniques to your own style – as Alan Brown did in *Central Station*, when he used the ancient American Indian mola technique – can lead to refreshing and invigorating results.

This is a milk-like liquid which dries to a colourless, transparent and glossy finish. It has no effect on the colour and dries within one hour. Use a soft-haired brush. Clean brushes in water.

Fixative for charcoal and crayon This is a diluted solution of colourless resins, mainly in alcohol. Is available in bottles and atomisers. It is fast-drying, colourless and non-yellowing. Do not spray more fixative on the surface than is absolutely necessary to ensure good adhesion and reasonable resistance to smudging.

Designer's colour varnish This varnish has colourless synthetic resins, dissolved in white spirit, as its base. Available in both glossy and mat varieties. A matting agent is added to the mat varnish. The glossy varnish darkens the colours a little and also makes them a little more transparent. The mat varnish has little effect on the colours. The varnish dries within a few hours. Brushes should be washed in white spirit.

Lofoten Fishermen Hauling in the Nets – 1936
ROLF NESCH

Nesch assembled this composition from various pieces of metal and wire which he soldered onto a zinc plate.

Varnish for oil paint Most varnishes for oil paint consist of non-yellowing synthetic resins.

Some have matting agents added to them. Dammar varnish is based on natural resin. Use a soft-haired brush when working with these varnishes. Clean brushes with white spirit or turpentine.

Acrylic varnish Contains acrylate resin dispersions, dissolved in turpentine, etc. It is available in glossy and mat varieties.

The mat varnish contains matting agents (silicates) which give the painting a satin gloss. Wash varnish brushes in white spirit or turpentine.

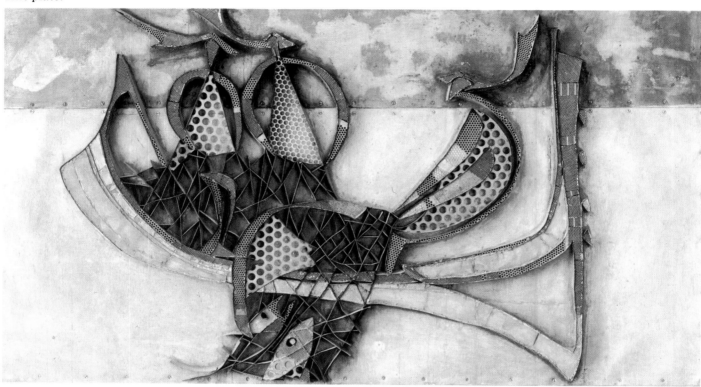

Material trial **XXII**

This is a trial piece for those who have found new possibilities through a lot of experimenting with materials.

BASIC MATERIALS

BRUSHES

There are many different types of hair which can be used for brushes intended for working with paint. The brush you choose must be suitable for the thickness of the paint you intend to work with and the technique to be used. Special brushes for varnishing are available.

TYPES OF HAIR

Kolinsky The tail hair of the Kolinsky (Siberian mink) is very elastic and is strong, supple and durable. The hair ends in a fine, rather dark point. It is the most expensive type of hair used in the manufacture of brushes.

Red sable This hair is obtained from animals in the sable family other than the Kolinsky. This hair is often reddish in colour and, like Kolinsky hair, it is supple and elastic. It is also strong and durable. The hair ends in a fine point. Red sable is surpassed in quality only by Kolinsky hair and it is therefore one of the more expensive types of hair.

Weasel hair Weasel hair has the same properties as red sable hair. The point is darker.

'Im' red sable hair The words 'Im' red sable on a brush do not mean 'imported' red sable hair, but refer to the fact that the hair is 'imitation' red sable. This is usually dyed ox hair or a mixture of red sable and ox hair. Sometimes other types of hair are incorporated. If the precise type of hair is not known, then it is impossible to determine the properties of 'Im' red sable.

Polecat hair The tail hair of the polecat is whitish-grey at the root, blended in the middle and either blackish-brown or very light in colour at the tip. It is a rather expensive, fine, soft hair which is less elastic than red sable. The hair holds paint well. Polecat hair is less durable than Kolinsky or red sable hair.

The tail hair of other members of the squirrel family (Feh hair) is used in brushes. This is a very fine, soft hair but is not as elastic and is less durable. The colours are blended from brownish-blue to greyish-blue.

Goat's hair Goat's hair from South European countries and China is black or white. (The white hair is dyed black.) This type of hair is incorporated into Chinese brushes and varnish brushes among others. It is a very fine, soft hair which takes up moisture well. It is not durable and is a relatively cheap type of hair.

Camel hair The words 'camel hair' are sometimes found on brush handles. This is something of a mystery because this hair has nothing whatsoever to do with camels and is not even the same colour! It largely consists of pony hair and varies in colour from reddish-brown to dark grey. It is a regular type of hair but is not very elastic or durable. Camel hair is used in cheaper types of brushes, mainly in school brushes.

Ox hair The best types of ox hair are clipped from the inside of cows' ears. The tip, which is often light in colour, is finely pointed.

In general, blond hairs are of better quality than dark hairs. Ox hair is soft and supple but not particularly elastic or durable. Nor does it retain its shape too well. It is, however, a good, cheap alternative to the more expensive red sable hair and is particularly suitable for use with fairly thin paint.

Hog's hair Hog's hair is stiff, thick hair; each hair ends in two or more points. The best sort is bleached Chinese hog's hair (Chunking). Brushes made with stiff hog's hair are suitable for using with the paste-like types of paint.

Besides those already mentioned, many other types of hair are used in the manufacture of brushes. These are usually types of brushes which are used for special techniques such as technical drawing. Among other types of hair, that of the badger and bear are used. Less durable, often blended, hair is incorporated in very cheap brushes.

Filament Filament is an alternative to natural types of hair. This polyester fibre was developed in Japan during the 1970s. Filament is a very good alternative for those who, for environmental reasons, object to the use of natural hair. It has many properties in common with red sable: it is supple, elastic and durable and retains its shape well.

However, it holds moisture less well which means that paint has to be taken up more frequently.

BRUSH SHAPES
There is a great variety in the shape of brushes as well as in the types of hair from which they are made. The shape depends on the type of hair and also on the sort of paint or the technique for which it is intended.

There are both flat and round brushes with long and short handles. Long-handled brushes have the advantage of allowing you to work at a greater distance from the support so that you have a better overall view of your composition. Such a brush should not be held directly behind the ferrule – the long handle is there for a purpose! Keep your wrist loose and avoid holding or handling the brush in a tight, cramped manner.

The Gussow A Gussow is a short-haired brush with a long handle which is available with both flat and rounded ferrules. The hair in flat-ferruled brushes is cut at right angles. Gussow

brushes are manufactured from various types of hair. The more expensive varieties may be interlocked. This means that the hairs are tied in small 'bundles' and then fixed in the ferrule in such a way that because of their natural curvature the hair tips tend to point inwards. This helps the hairs to retain their shape and this method of fixing them in the ferrule considerably reduces the chances of the hair falling out.

The Lyons brush The Lyons brush differs from the Gussow only in that the hairs are longer. Apart from that it is identical and therefore a Lyons brush is known as long-haired Gussow.

A 'curved' brush is a flat brush in which the hairs are not all of equal length.

Pointed brushes Besides the round Gussow and the Lyons brush in which the hairs taper, pointed brushes are also available.

These are used with water-based paints and also for glazing with acrylic and oil paints. As a rule the more expensive the hair the more carefully the tapering point is prepared. The precision of the point is determined by the method in which the hairs are bound. The hairs in an expensive brush are never shaved in order to achieve a good point.

The stencilling brush The rounded stencilling brush is made of hog's hair which is cut at right angles. It has a short handle. This brush is used for stencilling, brushing and stippling techniques and is handled at right angles to the support.

The filbert brush A filbert brush (or 'cat's tongue') is a flat brush in which the hairs tape to a point from the sides. This shape imparts a particular form to the brushstroke. These brushes are usually manufactured from the more expensive types of hair but they are also made in filament.

The fan brush As its name suggests, this brush is in the shape of a fan. It is used, among other things, for spreading thin layers of paint over already applied dried layers of paint, charcoal or pastel. This can create smooth, soft colour transitions. To do this the brush is handled loosely. Fan brushes are available in red sable-hair, ox hair and Chunking as well as in filament. It is also known by the name 'badger brush'.

The spalter A spalter is a flat, broad brush with a short handle and can, among other things, be made of hog's hair, ox hair or goat's hair. The stiff-haired spalter is used for laying down large areas of paint which has a paste-like consistency and for varnishing a rough, structured paint surface. A soft-haired spalter is used to lay down large areas of paint which does not have a paste-like consistency and for varnishing a smooth paint surface.

The spalter is also known as a varnish brush.

THE NUMBERING OF BRUSHES
Brushes are numbered to indicate the thickness of the hairs. For some types of brushes only the even numbers – 2 to 24, for example – are used while with other types consecutive numbers – 1 to 12 or 24, for example – are used.

In addition very special brushes are manufactured – for miniature painting, for example – and the extreme fineness of these is often indicated by one or more zeros.

The lower the number of a brush, the less hair it contains. This can vary from manufacturer to manufacturer, however. A brush which is much thinner than you would expect from its number should not be purchased. If you are buying a good brush you have a right to expect value for your money.

That part of the brush at which the hair is at its greatest volume is the part which has the greatest elasticity. It is also the part of the brush that takes up the most paint. This point is just above the ferrule. This property is particularly important when the brush is being used with types of paint which contain water because the brushstroke can be fuller and longer.

CHOOSING BRUSHES As has already been mentioned, various types of hair and different shapes of brush can be considered for working with gouache and acrylic paint. Your choice of brush will depend on the consistency of the paint you will use for a particular painting technique.

1 Lyons brush – ox hair/2 Pointed brush – Kolinsky hair/3 Filbert brush – red sable hair/4 Fan brush – filament/ 5 Washbrush – goat's hair/6 Round Gussow – hog's hair/7 Flat Gussow – hog's hair/8 Stencilling brush – hog's hair/ 9 Flat Gussow, interlocked – hog's hair/10 Spalter – goat's hair

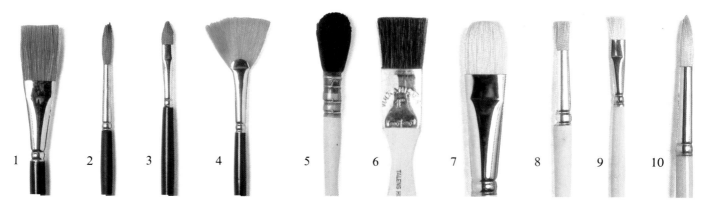

1 2 3 4 5 6 7 8 9 10

Working with unthinned or scarcely thinned paint requires strong, stiff-haired brushes. The stiff-haired round or flat Gussows and Lyons brushes are particularly suitable for this purpose.

When working with thinned paint, you can use soft-haired round or flat Gussows and Lyons brushes as well as soft-haired brushes intended for use with water-based paints. In this event the brushstroke will flow. The choice of hair depends on your budget. Red sable hair is the most beautiful and the best type of hair, but polecat, ox hair, goats' hair, and soft synthetic fibres like filament are also good.

For stencilling and brushing using fairly 'dry' paint, a stencilling brush is required. Gussows, Lyons brushes and stencilling brushes are available in various sizes. Working with paint which has a paste-like consistency is not conducive to the making of highly-detailed pieces of work. For this purpose, therefore, you must purchase more substantial brushes – size 12 and above, for example.

The broad, flat spalters are used for various purposes. Soft-haired spalters, made from ox hair or goats' hair, are suitable for laying down large areas of thinned paint, for varnishing your pieces of work and for impregnating your support. The brushstroke will flow. Stiff-haired spalters made from hog's hair are suitable for laying down large areas of paint which has a paste-like consistency and for impregnating supports that are rather rougher. The structure of the brushstroke remains visible.

The following points should be kept in mind when purchasing brushes:

The brush hairs are contained in a metal ferrule. In cheaper brushes this ferrule is nipped. The disadvantage of this is that if the hairs loosen during use, the ferrule also loosens and the brush loses its hairs. 'Cheap' then turns out to be expensive.

Brushes with a soldered ferrule, or better still a seamless ferrule, are therefore more suitable.

Always lay a new brush in water so that the hairs can settle in the ferrule and then shake the water out. If you do this you should not have any problems with hair loss while you are painting.

The purchase of expensive brushes,

especially those containing red sable hair, is not as straightforward as it appears. The term 'red sable' not only includes the hair from types of sable such as the Kolinsky, but also hair from other sable-like animals such as the weasel. Kolinsky hair is three times as expensive as the hair of other types of sable and can cost several thousand pound a kilo.

The various types of hair are not always easy to recognise. The hair is sometimes dyed which does not make it any easier for the layman. For this reason it is advisable to buy your brushes from a reputable supplier.

PAINTING AND PALETTE KNIVES

If oil or acrylic paint is worked in its paste-like form it can be applied to the support with a painting knife rather than with a brush.

Painting knives are bowed between the handle and the blade, and are made of very flexible metal. Various types are available and they can be used to apply interesting structures into the paint layer. A painting knife is also used to transfer a larger quantity of paint from the palette to the support. (Even if you are working with brushes it is also advisable to do this with a painting knife because it saves wear and tear on your brushes.)

Areas of paint which have not yet dried and which do not appear to be satisfactory can also be removed from the support with a painting knife.

Palette knives are straight, stiff metal knives and are used for carrying out processes such as the mixing of colours on the palette.

This saves wear on the brush hairs and not so much air gets into the paint. Remnants of paint can also be scraped off the palette with a palette knife.

A palette knife should never be used as a painting knife because this can easily damage the support.

SUPPORTS

Supports for drawing and painting are divided into flexible (such as artist's canvas), semi-rigid (such as cardboard) and rigid (such as hardboard and wood) supports.

FLEXIBLE SUPPORTS

TYPES OF PAPER Paper, depending on its type, is manufactured from a variety of raw materials including wood pulp, straw, grasses, rags and, in particular, cellulose. Many types of paper have size as a binding agent.

There are unsized types of paper and types which are weakly, normally or strongly sized. The less size a paper contains, the greater its absorbent properties.

Paper can also contain talc, kaolin (China clay) and calcium sulphate. These raw materials make the paper less translucent.

We distinguish between wood-free and wood-containing paper. Wood-free paper may not contain more than 10 per cent wood pulp (preferably 5 per cent). Wood-free paper is more durable and more expensive than wood-containing paper, which is brittle and soon yellows.

The surface of the paper can be smooth, rough or structured. The surface texture (pressing) of aquarelle paper can vary. Some types of paper such as, for example, casing and brown paper, have both a rough side and a smooth side.

Tinted paper contains colouring agents, the purity and resistance to fading of which determine its quality.

The weight (or 'grammage') of the paper is measured in grams per square metre (10,000 square centimetres). Irrespective of the paper format one speaks of paper with a weight of 85, 120 or 180 grams, for example.

Generally speaking, the greater the gram weight, the thicker the paper. A 50 x 50 cm (2,500 cm²) sheet of paper which has a weight of 180 grams actually weighs only a quarter of that – 45 grams.

All types of paper are subject to atmospheric conditions. Too much sunlight and humidity, in particular, will attack the paper and eventually destroy it.

It is therefore advisable to store both your drawings and your clean sheets of paper at room temperature in a folder. Framed drawings must be protected from humidity and direct sunlight.

A little knowledge of the various types of paper is required in order to choose that which is most suitable for

your purposes. For this reason there follow descriptions of a number of types which are suitable for working with gouache and acrylic paint.

Novel paper Novel paper is available in both wood-free and wood-containing types. The wood-free paper is a little smoother in texture. It is an absorbent type of paper which is suitable for making quick studies in thinned gouache and acrylic paint.

Casing Casing is a wood-containing, fairly strong type of paper which is used in the bookbinding industry for making endpapers. It is a light yellow ochre tinted paper and has a smooth side and a rough. It is not very resistant to fading. The rough side is suitable for working with fairly thick paint. The smooth side can only be worked with thinned paint; thick layers of paint can peel off a smooth paper surface.

Brown paper This well-known brown and yellow tinted type of paper has the same properties as casing and can be worked in the same way. Brown paper offers a cheap alternative to more expensive types of paper such as cover paper, drawing paper and Ingres. Brown paper is not very resistant to fading but this is not a problem when using opaque paint.

Cover paper Cover paper is manufactured in different colours in both wood-free and wood-containing varieties. It is not very resistant to fading and is therefore only suitable for painting if the whole surface area is covered in opaque paint. This paper absorbs moisture very easily because it contains relatively little size.

Ingres paper Ingres paper is a thin, but heavy type of paper and is available in white, black and a variety of colours. It is a 'laid' paper. This means that it has a lined surface texture which results from the pulp being drawn up through a fine wire mesh. This texture can be seen with the naked eye but is much more noticeable if the paper is held up to the light.

Ingres is a sized paper which only slowly absorbs moisture. Although it is one of the more expensive types of paper, its quality can vary somewhat.

The resistance to fading is of particular importance. This can be checked by exposing a few strips, half covered, to sunlight for a month or so. In this way you can discover for yourself which type has the best resistance to fading.

Ingres paper is suitable for working with slightly thinned gouache, watercolour and acrylic paint. With good quality Ingres paper, in particular, it is not necessary to cover the entire surface of the paper.

Drawing paper 'Drawing paper' is often used as a collective name for many different types of paper. It is wood-free and has a smooth surface. It is available in a large number of gram weights and is suitable for use with all the types of paint described in this book. As long as the drawing paper is not too light it can be worked with paint with a paste-like consistency as well as with transparent paint.

Rag paper Rag paper is one of the oldest known types of paper. It is manufactured from clean rags. It is very expensive and nowadays is actually used only for making security bonds and banknotes.

Although pure rag paper, which is one of the very best types of paper, is still available to a limited extent, nowadays paper which contains no more than 60 per cent rags is also sold under the name 'rag paper'. Rag-containing paper must consist of at least 15 per cent rag fibres. Rag paper and rag-containing paper can always be recognised by the tiny textile fibres visible in the surface of the paper. These types of paper are suitable for working with both gouache and acrylic paint.

Marbled paper This is also rag-containing paper.

Coloured textile fibres are added during the manufacturing process. This type of paper also is very suitable for painting techniques in which the paint is applied opaquely. Whether or not it is suitable when the paint is worked transparently depends on the percentage of wood pulp it contains. If this is too high the paper is too porous to be worked in this way.

Tinted drawing paper 'Tinted drawing paper' can be cover paper, Ingres paper or marbled paper.

Aquarelle paper Aquarelle paper was specially developed for watercolour painting.

The best varieties are wood-free. They undergo a special pressing which gives the paper its surface texture. This pressing can be fine, rough or very rough. Aquarelle paper is well-sized and therefore only absorbs moisture relatively slowly.

The heavier qualities, in particular, are eminently suitable for working with gouache and acrylic paint of a paste-like consistency. For working with more transparent paint, a lighter quality can be chosen. In this case it is advisable to first stretch the paper. Aquarelle paper with a rough pressing gives an extra texture to thinly applied layers of paint.

Ivory board Ivory board, which is also known as Bristol board, is a solid, smooth card-like paper which consists of a number of layers. It is a strongly bleached paper and is available in various thicknesses. This sort of paper is particularly suitable for paintings in which the paint is worked thinly. The brushstroke of stiff-haired brushes remains visible. There is insufficient adhesion, however, when paint layers of a paste-like consistency are applied.

Impregnated painting paper This type of paper, which is also known as oil painting paper, is impregnated with a universal primer.

It was specially developed for working with various types of paint and is available both in sheets of various sizes (50 x 65 cm, among others) and in blocks. This paper is suitable for gouache, acrylic and oil paint, as long as the paint is not applied too thickly. If it is stuck to a rigid ground such as hardboard or thick grey board, thicker layers of acrylic paint can be applied.

Smooth impregnated painting paper, paper which has a linen pressing and paper in which a linen or cotton weave is pressed, are available.

TYPES OF CANVAS

Most canvas is manufactured from linen, cotton or a combination of the two while synthetic materials such as rayon are now coming into use. Synthetic fibres, however, are not yet fully established because there is not enough evidence of their durability.

Canvas can be woven in various ways. Basically it consists of the warp (the yarns stretched along the length of the fabric) and the weft (the yarns laid across the fabric). The way in which these yarns are interlaced is known as the 'weave'. The most common weave used for artists' canvas is the 'linen weave' or 'flat weave' in which the weft yarns pass alternately under and over adjacent warp yarns. This creates a single yarn weave which is strong and uniform. A double yarn linen weave is used in some canvasses.

Artists' canvas is manufactured in various fibres and is available in fine, medium-fine, coarse and very coarse weaves. This depends on the thickness and the uniformity of the spun yarn and the number of threads per square centimetre in the woven canvas. The quality also depends on the length of the fibres in the original threads.

The usual canvas is 210 cm in width but there are also canvasses which are three to four metres wide. Usually these are only supplied to order, however. Canvasses can be bought both primed and unprimed. You can buy any length you wish from the roll and stretch it yourself. Canvasses which have already been stretched are available in a large number of formats. It is also possible to order non-standard formats.

Vegetable fibres consist largely of cellulose and are therefore subject to ageing. They are affected by oxygen in the air, changes in light and temperature and humidity. Nowadays there are also chemical processes which affect canvasses. Large changes in temperature and humidity cause the textile fibres to age more rapidly (stretch, shrink, break). If the temperature is too high the canvas dries out. This creates a high tension and the canvas can tear and cracks can also appear in the paint layers.

If the atmosphere is too damp the fibres can swell and the canvas sags.

This can happen at both high and low temperatures. In extreme cold the paint layer becomes hard and brittle.

(In museums the temperature is kept between 19° and 20.5° Celsius. The degree of humidity is maintained at between 50 and 60 per cent.)

Linen (*Linum*) Linen is made from flax, which is smooth, strong, flexible and has almost no 'stretch'. Artists' canvas made from linen is undoubtedly the ideal surface for painting in oils and acrylic paint.

There are, however, many different quality canvasses on the market and it is therefore advisable to buy your canvasses from a reputable specialist shop. Hold the canvas up to the light and check the closeness of the weave and the quality of the yarns. There must be no knots present in the weave because these can seldom be concealed – even when the canvas is impregnated – unless the paint is applied very thickly. The canvas should be fairly smooth and not too loosely woven. Pure linen canvas is rather expensive.

Hemp (*Cannabis*) High-quality artists' canvas can also be manufactured from hemp fibres, but nowadays hemp canvas is rarely, if ever, available because in many countries its cultivation is forbidden under the narcotics laws.

Cotton (*Gossypium*) Cotton fibres are the white seed hair fibres which are revealed when the boll or seed pod of the cotton plant splits opens.

Mounted cotton canvas tends to stretch, while painted cotton canvas can sag so much that it has to be re-stretched and even this is often insufficient to solve the problem. Cotton is not very resistant to the ageing process and therefore paintings executed on cotton canvasses do not have a long life. Because of this tendency to stretch, it is not advisable to use large-format cotton canvasses. They are only suitable for techniques in which thin layers of paint are applied. This type of canvas, however, is extremely suitable for mounting on rigid supports which to a large extent counteracts the ageing process.

Half-linen Half-linen canvas is a fabric made of cotton and linen. Ideally half-linen consists of 60 per cent linen and 40 per cent cotton but the percentage of linen is often much smaller.

Half-linen has the same drawbacks as cotton and one further disadvantage. The different fibres have a different dimensional stability – they stretch to a different degree – and this has a great effect on the 'sag' factor. But like cotton, half-linen canvas is an excellent ground for painting when it is mounted on a rigid support.

Jute (*Corchorus*) Jute consists of tough, stiff fibres which are woven into a fairly rough fabric. The fibres are very susceptible to humidity and jute canvas quickly stretches and sags.

Moreover, the fibres are not very resistant to the effects of oxygen and light. Despite these drawbacks, however, jute is valued by some artists, mainly because of its rough surface structure.

Because jute fibres are so vulnerable, a jute canvas must be well primed before it is used as a support for painting. Oil also attacks the fibres and therefore a universal primer which does not contain oil must be used. Gesso (Talens) is ideal. (An oil-containting primer should never be used to prime a support on which acrylic paint will be used!)

If the structure of the jute canvas must remain visible it must be given a few layers of well-thinned primer. The worst effects of humidity, oxygen and light can be prevented to a large extent by mounting the finished canvas on a thin sheet of wood or grey board in which a few ventilation holes have been drilled.

Synthetic fibres It is understandable that the search continues for synthetic fabrics which completely satisfy the demands imposed on them by humidity, oxygen and light.

Until now it has proved very difficult to achieve this aim but such a fabric will undoubtedly be produed sooner or later. Dralon and rayon fibres were a step in the right direction, because they at least solved the problem of humidity. Nevertheless, fabrics made from these fibres still lack a good dimensional stability. Furthermore, they have only been in

existence for a relatively short time and it is therefore impossible to determine their durability and resistance to other atmospheric influences.

Besides types of paper and artists' canvas, semi-rigid and rigid supports can be used. Semi-rigid supports include, among other things, cardboard.

Strawboard (cardboard) The well-known, ordinary brown cardboard is suitable only for making studies and must always be primed. The brown colour in the board can show through a gouache painting. Strawboard is very susceptible to atmospheric conditions. If it is damp, strawboard swells and the painting will be destroyed. In the long run this material desintegrates.

Hardboard Like chipboard and fibreboard, hardboard is made from pressed wood fibres. It is available in sheets which you can have cut in various sizes. The width of these sheets is determined by the capacity of the machine on which they are prepared. In most European countries the standard size is 122 cm. Hardboard forms a suitable right support for working with gouache and acrylic paint. Both the smooth and the rough surface can be used provided they are primed. It is not always necessary to use a rigid support for gouache because this medium cannot be applied in thick layers. Good, heavy types of paper or cardboard usually form a sufficiently adequate support.
 Without the support of a wooden framework hardboard in formats greater than about 50 x 65 cm can warp.

White board and grey board White board and grey board are types of pressed cardboard and are available in various thicknesses. Provided that they are first primed, they are suitable for working with both gouache and acrylic paint. Choose a somewhat thicker type that is less liable to warp. Board which has paper glued to its is also available. If too much water is used for thinning the paint, however, the layer of glue between the paper

and the board can dissolve. It is therefore better to use board which is not covered with paper.

Canvas board (Universal board) Canvas board, which is also known as universal board, consists of a sheet of cardboard covered on one side by a primed cotton canvas. Paper is stuck on the back of the board to prevent warping. In the first place, canvas board is a good support for the making of studies but it can also be used for making paintings which will be preserved for a number of years.
 Nevertheless, it is a material which easily attracts moisture and it is therefore susceptible to changes in temperature.

Rigid supports include various boards and wood. In general, these types of support must be primed before they are suitable for painting.
 Rigid supports can be covered with paper or fabric before they are primed.

Wood For a long time wooden panels served as supports for tempera paintings and oil paintings. Artists' canvas only appeared during the 15th century. Nowadays, really good wooden panels are rarely available. If you are very lucky you may perhaps come into possession of a few beautiful panels. These usually come from old wooden pieces of furniture and have been worked with oil, varnish or wax. If you wish to prepare such a panel for use with, for example, acrylic or oil paint, then it must be leached, sandpapered and filled.
 New, green wood is not suitable as a painting surface. It contains too much moisture and resin which causes it to 'work'. Cracks develop in the wood and the paint layer can blister and flake.

Plywood Plywood consists of a number of thin layers of wood which are glued together and is often used as a support for paintings. As long as it is well impregnated, plywood provides an acceptable support for the making of studies. Do not, however, use plywood as a support for pieces of work that must stand the test of time.

It is impossible for laymen to determine the type of glue used in the manufacture. Plywood panels can be affected by moisture and this can loosen the glue. Glue can also perish which causes the panels to split. Moreover, it may contain acids that can attack the paint layer.

Waterproof plywood Besides the normal types of plywood, waterproof plywoods (marine plywoods) are available. These are suitable to use as rigid supports because they do not have the drawbacks of the ordinary types of plywood.

Blockboard Blockboard consists of narrow parallel strips of wood glued edge to edge and faced top and bottom with thin sheets of veneer. This construction is rigid and blockboard panels do not warp. As with plywood, however, the glues used can be open to question. The wood used is not always water-resistant. This material is suitable, however, for the making of studies in acrylic and oil paint.

Chipboard and fibreboard Chipboard and fibreboard can both be used as rigid supports. The material, however, is of relatively recent origin and it cannot be assumed that it will stand the test of time. It can be tentatively supposed that as long as the board is well impregnated a painting will survive for some sixty years and probably much longer. Bear in mind that chipboard particularly is a heavy material and large formats are difficult to handle. This problem can be partly overcome by using boards which are not too thick. Large format boards can bend and therefore must be strengthened with supporting wooden strips. Chipboard and fibreboard are eminently suitable for applying impastos in thick layers of acrylic and oil paint. This type of support must be handled with care. It is composed of pressed fibres and the corners can be easily damaged by rough handling. It is best to protect the corners with strips of wood.

PRIMING, MOUNTING, COVERING AND STRETCHING

PRIMING Highly absorbent surfaces may soak up too much binder from the paint and before working with gouache they must therefore be primed with a thin layer of Designers' colour medium (Talens).

If you are working with acrylic or oil paint, a suitable primer, based on synthetic dispersion (Gesso – Talens), is necessary. Oil-based primers are not suitable when acrylic paint is used.

Both flexible and rigid supports can be primed. Thin a little Gesso with water in a bowl until it is fluid enough to brush on easily. Use a spalter.

Paper Lay the sheet of paper on a smooth ground and fasten the corners to stop the paper rolling up. Brush a thin layer of Gesso over the paper and allow it to dry. Then brush a second layer of Gesso at right angles to the first. Let the paper dry thoroughly.

Turn the paper over and prime the reverse side in the same way.

Rigid supports Wipe the support down with a little methylated spirits or ox gall, sand the surface smooth with a piece of fine sandpaper and dust it off. Even if the surface is very smooth it is still a good idea to sand-paper it because the primer adheres better.

Apply the first layer of gesso and sandpaper it into the surface. When the first layer is thoroughly dry, apply the second layer at right angles to the first. Let this dry thoroughly before you begin to paint. Some painters apply more layers of primer and sand-paper them all. This gives a lovely smooth surface. If you wish to work on a rough support, then you can use, for example, the back side of hard-board. In this case the layers of primer are not sandpapered. A soft-haired spalter is used to prime a smooth surface and a stiff-haired spalter to prime a rough surface.

Canvas
a) *Prepared artists' canvas* is usually provided with a thin layer of primer by the manufacturer but before you begin to paint you must prime the canvas again with a synthetic-based primer. This is because there is a con-siderable chance that the layer of primer applied during manufacture is insufficiently thick and because it is not always possible to determine if the right primer has been used. This is not always visible at first, but in the course of time the acrylic layer will inevitably peel away. Before you prime the canvas, degrease it. Allow this to evaporate or wipe the canvas dry. When the canvas is thoroughly dry, sand it lightly with a piece of fine sandpaper or a piece of pumice stone in order to promote a good adhesion between the textile fibres, the original layer of primer and the layer of pri-mer which is to be applied. Then ap-ply the first layer of primer. When this is dry apply the second layer at right angles to the first. If you want a very smooth surface you can sand it lightly after it is dry so that the struc-ture of the spalter hairs is less visible.
b) *Unprepared artists' canvas* The quality of unprepared canvas is easier to determine than that of prepared canvas. To protect the canvas fibres and to promote good adhesion be-tween the canvas and the paint, the canvas must be provided with a good ground.
You can prime a canvas in two ways:

Working method I By applying a synthetic universal primer directly onto the canvas; it must be applied in a thin film.

Rougher canvas is more absorbent than finer canvas and therefore with rough canvas it is necessary to thin the primer well with water to form a thin, smooth paste. Apply it evenly using a broad spalter. When the first layer has dried, apply the second layer at right angles to the first. If neces-sary, apply a third layer at right angles to the second. The third layer can consist of somewhat thicker gesso. It can be applied with a spalter, an ink roller or a painting knife – the choice is yours. Applying or working the third layer with a painting knife makes the surface of the canvas smoother. The canvas must be stretched a little while it is still wet because the moisture in the primer causes it to sag somewhat. This is done by tapping the wedges (keys) in the stretcher frame until the canvas is fairly taut. If you wish you can then sand the surface with sandpaper or pumice stone. If you intend to use a more paste-like paint, however, this is not necessary.

Working method II By first sizing the canvas and then priming it. When a canvas is sized it is stiffer and less springy during painting. It is stretched but elastic, rather like a drum. Pre-sizing is particularly recommended for canvas which has a loose, rough weave because a rough weave absorbs too much primer.

Hare or rabbit skin glue was orig-inally used for pre-sizing, but nowa-days these are difficult, if not imposs-ible, to obtain and have been replaced by other types of animal glue such as gelatine (usually made from the bones of cattle).

To make the size, allow 70 grams of glue to soak in 1 litre of water. You can also allow the glue to soak in 1/2 litre of water and then add 1/2 litre to it. If you use glue flakes or lumps this process takes about 24 hours, glue in powder form takes only a few hours. After soaking, the glue is heated in a bain-marie (special pans are available in specialist shops) and all the glue particles dissolve completely in the water. The heated size is now applied to the canvas with a spalter. In order to avoid uneven flexibility you must work from the centre of the canvas to-wards the edges. Apply the size as evenly as possible. Allow the canvas to dry between 12 and 24 hours. Do not try to accelerate the drying time by placing the canvas near a source of heat as this can cause the layer of size to flake off.

Clean the sizing brush in warm wa-ter. Any size left over can be saved, particularly if you add a few drops of liquid disinfectant to it. Finally, the canvas can be primed with gesso.

If it sags during drying, then stretch it a little by tapping the keys in the stretcher frame. When it is completely dry the canvas will then be tautly stretched.

MOUNTING Paintings on flexible supports are usually done in thinned gouache and acrylic paint. It is best to mount gouache paintings behind glass because the paint is not water-resistant and is easily damaged. Acryl-ic paintings are water-resistant and can be framed without glass. It is par-ticularly necessary to glue large-for-mat pieces of work, made with paste-

like paint, onto a rigid carrier.

Although it is simpler to mount un-worked paper, in practice mounting completed pieces of work will occur more often. Only supports which have a thin layer of primer on the reverse side are suitable. If this is not present, flecks in the support – and therefore in the piece of work – can appear during mounting.

You need a strong carrier which will not bend when a piece of work is glued to it. To be on the safe side, prime the carrier on both sides in order to counteract absorption of the glue.

Work can be mounted with decorator's size, paste, synthetic resin glue or primer. Apply a good coat of size or primer to the carrier.

This should not be too thin but still fluid enough to brush out easily using a stiff-haired spalter. Lay the paper carefully on the carrier. Cover it with a sheet of clean paper and brush it out smoothly, working from the centre. Lay the mounted support flat under a board. This exerts a little pressure and helps the paper to adhere well to the carrier.

COVERING If you want more structure in the surface you intend to paint on, the support can be covered with cotton or linen. Half-linen and synthetic fibres stretch when mounted on a stretcher frame, but they are extremely suitable for mounting on a rigid carrier as the tendency for these materials to stretch is then neutralised. New fabric often contains aprêt which can resist the absorption of acrylic paint and it must therefore first be washed in a pure soap solution and well rinsed in lukewarm water. Do not wring the fabric out but stretch it to stop it creasing. Unless it is absolutely necessary the fabric should not be ironed so that the fibres remain open and absorb the primer better. Heavy cardboard, hardboard, fibreboard or chipboard and plywood are all suitable as carriers.

Working method Cut the fabric to size, allowing an extra 3 cm for folding over. Use universal primer as the sizing agent. This is an excellent adhesive and has the advantage that no unforeseen reactions can occur. Thin the prime with a little water until it is just fluid enough to brush on

easily. Sand the carrier down a little so that it can absorb the primer well. Lay the fabric, the good side downwards, on a flat surface covered with a sheet of clean paper. Brush a fairly thick layer of primer on the carrier with a stiff-haired spalter. Lay the carrier, the sized-side downwards, on the fabric. Turn the carrier over and brush the fabric flat so that there are no creases or air bubbles. Turn the carrier over again and cut the corners off diagonally allowing about twice the thickness of the carrier extra. Fold one long and one short side over and carefully smooth down the corner. Do the same with the other two sides. Let the covered carrier (the support) dry and then prime it.

If the support tends to warp when it is covered only on one side, glue a sheet of paper on the reverse side.

Cut the paper a little smaller than the format on the support. Thin primer or size to a watery consistency, apply it to the paper an allow it to soak in. Brush the paper once again with the watery size, lay it on the support and press it down smoothly with a cloth.

Sometimes you may prefer to work on a tinted support which offers you the opportunity to leave parts of the surface unworked. For both gouache and acrylic paintings you can tint the primer by stirring in a little acrylic paint. This gives a toned down colour which is ideal for painting over.

STRETCHING Stretching your own canvasses has many advantages. You cannot only determine the format of your painting yourself, you can also decide the type of canvas you want to use and you can prime the canvas to your own specific requirements.

A stretcher frame consists of 4 stretcher pieces and 8 wooden wedges called 'keys'. The stretcher pieces, depending on the size of the stretcher frame to be made, are 3½, 5 or 8 cm in width. Large frames also have one or more cross bars to strengthen the frame and keep it square.

The first time you stretch a canvas, choose a piece of fine linen because this is easier to handle than stiff canvas. Then try to stretch an unprepared canvas. Make sure the textile fibres are at right angles to the stretcher and as far as possible try not to distort the fibres.

Working method The piece of canvas must be about 10 cm longer and wider than the format of the stretcher frame, so that you have about 5 cm of material for folding over. You also need short tin-plated or steel flat-headed tacks, a small hammer, a tape measure or a metal set square.

Assemble the four stretcher pieces so that they form an oblong. Put two keys in the grooves in each corner and tap them in with a hammer. Measure to see if the frame is squared up. You can do this by checking the four corners with a set square or by measuring the distances from the bottom left-hand corner to the top right-hand corner and the bottom right-hand corner to the top left-hand corner.

Tap the keys in a little further and again check that the frame is square.

Very large frames can be checked by fixing two strips of wood to the floor at right angles to each other or by drawing a right angle with chalk.

Now lay the frame, front side down, on the back of the canvas and tap in the tacks, in the order shown in the illustration. Check to make sure that the frame is still square.

The tacks are put into the edges of the stretcher pieces. Do not tap them in fully, however, so that any mistake in the stretching will be easier to rectify. Only when there is an even tension should the tacks be driven completely home.

Now fold the corners over and tack them down.

You can use staples instead of tacks. These should be stapled in the same order as that followed with the tacks.

It is more difficult to rectify mistakes in stretching with stapled canvas because the staples first have to be removed.

Once the canvas is mounted on the stretcher frame it is tensioned by tapping the keys in further. Larger canvasses cannot be stretched by hand, particularly if they are of a stiff material. A special tool is used to tension the canvas before driving in a tack.

Cutt off any excess canvas along the back edge of the stretcher frame.

Degrease the canvas before giving it an extra protective layer of primer.